Through Waters Deep

Erin Leigh Shafer

ISBN: 978-1-60920-091-6

API
Ajoyin Publishing, Inc.
P.O. 342
Three Rivers, MI 49093
www.ajoyin.com

Please direct your inquiries to admin@ajoyin.com

Table of Contents

I wanted to dedicate this book to the amazing women who have fought this battle or will fight this battle someday, to the survivors, and to those who have lost their fight. Arm and arm we continue to walk toward a cure. May the men, women, sons, daughters, sisters, and brothers—everyone touched by cancer—continue to be a voice of awareness and hope, for today and forever.

Megan, Misty, Phyllis, Cheryl, Dana, Vickie, Dawn, Kim, Darla, Patricia, Diana, and all of my pink ribbon sisters . . . keep fighting.

Much love,
Erin

Acknowledgments

Books are never compiled, thought of, or written by just one person. The same is true for the completion of this book. My name is given as the "writer" but there are so many people to thank, recognize, and to honor who deserve the credit of this book. My sincere and humble apologies if I have left anyone out.

My family—Aaron, I am honored to be your wife. I love you and thank you for standing by me every step of the way. "Through sickness and in health" is something we have lived together and struggled through, but because of your faithful commitment, we have seen the covenant side of marriage that few people ever get a glimpse of. We have cried buckets of tears, laughed until our sides ached, and learned to live life because of this. Who would have thought? I am honored to serve at your side as you pastor at our church. I am overwhelmed and a little concerned whether they really knew what they were getting when they called us, but let's go, my wayward man . . . and embrace what lies ahead! And, in case you were wondering, I would still say yes all over again. To my sweet, little boy, Cade. You are such a sunshine! I have loved to watched you grow and carry the weight of the world on your shoulders as we walked this road. You'll never know just how much you kept me going. Your sweet love was "life" to me on more than one

occasion. You have the same desire to laugh as your mama. I love you a million red skittles, to the moon and back and beyond. To our families: the Shafers, Eichorns, McDonalds, Wilsons, Pattersons . . . and everyone we have adopted into our "family." We are a crowd when we get together. A force to be reckoned with, for sure!

My friends—Rachelle Dietz, Sarah Arreoles, Deanna Gilliam, Lisa Skeens, Jana Jennen, and Teresa Hurst, You guys have carried me, and have taught me how to be a better friend. There are times where no words will suffice. This is one of them. Thank you for carrying me and my family and loving us. I love you guys.

My church families of Moorepark Community, Lawson Baptist, and Lawson Bible: complete and humble gratitude for each and every card, note, meal, phone call, e-mail, text, or childcare provision that you all saw need of and gave, for me.

My team of doctors: Dr. Owen, Dr. Hubbard, Dr. Cozad, Dr. Hodge, Dr. Eason, Dr. Olhausen. The nurses: Mary Ann, Sue, Pat, McLaine, Kris, Trish, Shelly, Liberty, Julie, Darla, Teresa, Laura, Melissa, Lisa, Patty, Shirley, Denise, Sue, Kimber, Beth, and Tammy. You all still amaze me at what you do. "Life" has a new meaning.

Most of all, to You, Lord. Without You, I am truly nothing. All praise, honor and glory are Yours alone. May the words of my heart be pleasing to You, and full of grace. May the readers be blessed solely because of Your life-changing grace and finished work on the cross. This is YOUR story, and I am honored to be a part. Thank You for allowing me to tell it. My heart overflows to You. We have walked through waters deep, and You have proven

Yourself over and over. You have taught me to love myself as YOU love me, and I will never be the same.

Love,
 Your Girl

THROUGH WATERS DEEP
Introduction

This has been a long journey. I have hated it, yet would never change a thing about what I have learned. Tough? Incredibly so. Scared? Beyond reason. Hope? Now overflowing.

Many have asked me to write a book. To be honest, I have no idea why, yet the more I processed it and prayed over it, I knew for certain that this was what I was to do. You see, walking through breast cancer myself, I have seen far too many broken and bitter people called "survivors." I don't blame them. I know, because I have been stuck there myself. It is an easy trap for willing and unwilling parties alike.

From the beginning, I knew the Lord was in this and was going to show me "the goodness of the Lord in the land of the living." (Psalm 27:13). He is in control of ALL things. I didn't know what that meant at the time. Would I live? Would I die? What was going to happen? I had questions, but few answers. I still do.

These pages hold my story and my experience. By no means is this a how to guide, or step-by-step guide. Please do not use any information in this book as a cure or take this beyond its intended purpose. This is a candid picture of my own life through the eyes of Breast Cancer.

Journal entries, emotions, songs, scriptures, encouragement from friends, everything enclosed is for you to be encouraged. To give you hope. I don't know why God "appears" to work miracles in some lives and not in others. That is something that I have resolved to leave to Him alone. He is God. He is sovereign. I didn't hold back the ugly in the following pages, simply because I didn't want to tell a lie. This journey is far too heavy and far too long to add any more baggage along the way. It is a glimpse into some of what is experienced—at least through my eyes—when dealing with cancer.

Cancer can take a lot from you, but it will NEVER define who you are, unless you let it. You can decide to live with cancer, or to let cancer live with you.

Don't Look Back
(Just use the rear-view mirror once in a while...)

Chapter 1

I remember the careful attention we spent on every detail while building our dream home. It seems just like yesterday. From the particular stain of the wood-grained ceiling in the formal living room to the toilet handle in the guest bathroom, it was beautiful. It still is. And then came the day we felt the Lord calling us to sell it. Our dream. Our work. Our pride. All hung out to dry on a cheap, metal realtor's sign posted in our twelve acre front yard: "FOR SALE."

We didn't even know where we were going.

We still don't. But at least now we know Who we are following. Back then we were simply trying to keep our heads above water. And speaking of water, why is it that when the rain starts coming down, it rains in buckets? Not the simple, sweet, refreshing rain that comes at just

the perfect moment, just in time to quench the dry land and give relief from oppressive heat. Rarely is there a perfect moment for buckets full of water.

Ice cold.

Miserable.

Drenching buckets of rain.

We prayed. We went to church. Why did it seem like all at once the heavens opened up and dumped on us? "Really, Lord? The house that everything worked out just so to build?"

The house sold within eight months. Packing was made simple, thanks to my OCD ways (which, by the way, I like to refer to as "Overly Concerned Desires"). Moving was more of a chore, simply because we had to get the help lined up with the weather and move the cows and their calves, as well as clean the old house and the "new."

I will never forget that last moment of standing in my dream kitchen. Leaving all the keys carefully tucked inside the old utensil drawer was sort of like leaving a piece of me there also as I closed the back door one last time. Every nook and cranny was spotless. I even had cleaned the attic space. Oddly enough, I didn't feel terribly sad. I had more of a feeling of accomplishment from building our dream home, mixed with a feeling of certainty that the Lord was moving us into greater things while we left those former dreams behind.

I could almost hear an orchestra playing softly in the distance as I walked out that last time. Down the two handmade, wooden steps, across the wide expanse of a freshly swept and mopped garage floor. Over to my regular parking spot which held my friend's car, which I had

borrowed that day (mine was out of commission). With my head held high, tears at bay, I never looked back . . . even when I ran my friend's car right into the edge of the garage, knocking it off its foundation. (You could probably add some inappropriate laughing by now.)

Another bucketful.

Aaron and I often recall that time in our life with laughter amidst the tears, pain, and frustrations. He will shake his head and close his eyes, while I throw my head back with something that sounds like a cackle/laugh. Almost three years have passed since that day. We have seen many ups and downs, though not all quite as destructive. But the days of laughter? Many times over. Those are the times of refreshing rains.

Don't you love the smell of rain coming? Everything about its arrival is anticipated. The color before the storm. The feel of the air around you. The smell of the moisture stirring in the breeze. That sweet, sweet aroma of blessing. Rain providing relief from a warm spell similar to the way remission made me feel. Everything about it made my senses come alive. I like the way it feels on me. As many do.

My hair is growing back.

My uterus is gone . . . among other things.

And my "girlz" have been reconstructed.

I have so much to be thankful for. So incredibly much. And I am. I am thankful beyond words.

I just recently finished crying buckets of my own rainwater to my husband. We have been selectively wading through the "for worse" of this season, while clinging hopefully to the "for better" times to come.

I realized I have been continually trying to LIVE in my own strength. Sort of like trying to move forward, while at the same time not letting go of the past. Or like backing a car into a wall that will not budge (any further). I was grieving for my old life. I liked my long, albeit sometimes frizzy, hair. I liked being fit and knowing what worked for my body and not having to worry about surgery and who would be bringing meals or taking care of my boy.

It hurts.

I miss it.

I long to go back to the days before cancer ever entered into my medical portfolio. Back to the days I could be ignorant, for after all—isn't that supposedly bliss?

Now how in the world would I tell Aaron about the garage? I didn't want to have to explain how it happened when I wasn't sure myself. I had two witnesses, but they were of no help in that moment. We attempted to lift the side of the house with two screwdrivers and a wrench before calling him, but we still had to make the call. We could only move the dirt around the broken wall. That wasn't going to get us very far.

I could hear my grandpa McDonald saying, "Erin, in life you have to learn to become part of the solution, not part of the problem." Thanks, Gramps, I could have used that BEFORE I hit the side of the garage, and it sure would have come in handy BEFORE that darned wall slipped off the foundation.

Now what?

Well, let's suffice it to say that sometimes in times of refreshing rain, we need to learn to sit and soak it up

without reliving all the reasons why we needed refreshment in the first place.

The necessary repairs were made to the garage wall.

The healing is still taking place inside my heart and my body.

The hot flashes now come in buckets in place of the rain or even the tears, but I am learning to LIVE, not in my own strength anymore, and in that simple, four-letter word, I am learning to love myself as Jesus does—which is proving to be just as big a battle to fight as cancer, forfeited dreams, and a broken garage wall.

God is good and still stands as a refuge. When we surrender. When we fall. When we determine to keep running. Running after Jesus. Running into the rains of His refreshing. He calls forth the winds and the rains, and they obey Him.

Sometimes the darkest part of the night is right before the morning, which casts a welcome beacon of light on His new and wonderful mercies. Can you feel it? The rains are coming. Let's run, my friend. And don't look back (unless you are in your garage).

Miracles and Mammograms

Chapter 2

"The Lord also will be a refuge for the oppressed, a refuge in times of trouble. And those who know Your name will put their trust in You; For You, Lord, have not forsaken those who seek You" (Psalm 9:9–10 New King James Version).

I love reading the last chapter of a book. I have to know who is going to make it in the end so I will know who to put my trust in or my money on if I were the betting type. Some may object and say that I ruin my own surprise, but I argue right back with, "But the journey getting there is what captures my attention!"

My journey began right around my thirtieth birthday. I had no idea about an ending to this journey, but I was looking forward to a wonderful year with my family and friends, and of course setting goals and renewing

dreams. I remember specifically the bright, May morning on the day of the big three-oh. I didn't feel a bit older. In fact, I almost felt an unsettledness, or a restlessness. I wasn't sure what was causing this. My mind raced over the past year or so and couldn't come up with a definitive answer. The feeling subsided as the months rolled by, right into the Thanksgiving holiday.

My grandmother lives in northern Mississippi, miles from my own family. This year we decided to pack everyone up and meet down there to celebrate. With a big and growing family, there is much to be thankful for. While we were visiting I had developed a cold. You know, the kind that hangs on and annoys you for weeks. I had swollen lymph nodes in my neck, chin, and under my arms, not unusual for a good-sized cold, but certainly not something I was thankful for at the moment.

One evening while we were sitting around her back porch and singing song after song, playing a multitude of instruments, the feeling returned with such force that I began to cry. My mom had just finished sharing a sweet memory of my grandpa (her father) before he passed away. Remember the sage advice I shared from Grandpa Mc? Yes, that's him. Only now he is gone. He would sing bass as we would sing out "Amazing Grace" to the tune of "The House of the Rising Sun." Almost two decades later, we still miss him. Perhaps even more. He loved music and encouraged each of us in our pursuits and dreams, but would end the conversation with a little whistle that slipped between his lips. He didn't have to say a word. His eyes did all the talking.

As I prayed out there on the porch and hummed along,

I was hoping the feeling was just nostalgia, not the lingering "premonition/discernment feeling" from my birthday. It wasn't just the emotion, because I began to look around the room and feel the weight of it. I felt in my heart that it wasn't a death, but a sadness that would affect all of us. Little did I know that two weeks later our lives would be upside down and in a panic, just like my cousin Austin.

When Austin was little, we used to tease him that we were all going to die in a tornado. He was relatively young, and in his cute, southern accent used to scream through the house, "A tornado, A TORNADO! We're all gonna die!" I know. What a sick way to tease, but when you lacked maturity, like the rest of my siblings—ahem, you just did silly things like that.

Remember the swollen lymph nodes? They didn't go away under my left arm. To say that I am a hypochondriac would be a stretch, but not much. Up until this point I had struggled again and again with fears surrounding some sort of sickness or calamity. I had gone in to the doctor with all sorts of strange things, only to have them give me that sympathetic look, tell me everything was okay, and send me out the door. Did you notice the word pathetic hidden in there? Yep, that was me. It isn't a wonder that poor Austin was plagued by the same fear of death. He had learned from the best and was tormented by the worst.

Dr. Owens is the type of guy that reminds me of Max Lucado. Wise, often funny, with a calming persona around him. After the visit he decided that I should get a more thorough examination by having a mammogram

and an ultrasound done. Still not thinking it would be anything, I was scheduled for the next afternoon, with Dr. O'Malley.

I have always heard that hindsight is better than foresight. In the case of mammograms, I agree with the popular opinion that you should wait until you are forty to have them, yet at the same time believe that perhaps the initial screening should take place at twenty-five, so a baseline can be started. They are rather uncomfortable. I will spare you the details, but suffice it to say that uncomfortable is a gross understatement.

The mammogram and ultrasound showed calcifications, fibrocystic changes, and a small mass, not to mention two swollen lymph nodes. My appointment began at two thirty, and by five o'clock, I was pretty sure something wasn't going right. In the course of those few hours, I was moved from the mammogram room to the ultrasound room and back again multiple times. "We need to get some clearer pictures." "We thought we saw a shadow or something." "I am just taking some measurements."Hmmmm . . . (long pause)" the doctor will be in shortly."

I am not the sharpest tack in the drawer, but by this time I had figured out that I was dealing with more than "just a cold." When the ultrasound tech left the room, I just started to cry. I was scared, by myself, and was terrified of what the doctor would say. Not even two seconds later I felt as if someone was in the room with me. I tried to push up from the bed to look around, but since my arm had long since fallen asleep, I had quite a time glancing around for intruders. I then started feeling

a warmness—kind of like a heated blanket—from the inside out. A hug would be the closest description . . . but like I said, it was from the inside. Strange. I closed my eyes, and the first thing I saw was a face. Smiling at me. I remember distinctly hearing in my heart and mind these words, "Erin, it's okay. You are going to be okay; just wait and see what I am going to do with this."

When I was growing up, we were taught to pray by using sample prayers, those that our parents would repeat and help us with, along with several nursery-rhyme-like recitations. Through the years of growing, maturing, and simply having more practice with prayer, I began to talk to the Lord just as if I were talking to you or another friend on the phone or in person. Just me and Him. I tell Him everything and anything. Right at that moment, I just cried out to Him from the depths of my soul. "Lord, if you are smiling when they think I have cancer, you have a SICK sense of humor. I am NOT laughing here. What is going on? Why me? Why now? Aren't I too young for this?" I didn't hear anything back. Just sweet, sweet peace.

Dr. O'Malley came in with a poker face. The dead giveaway was when he started patting and rubbing my leg, and his nurse came over with a whole Kleenex box and began to rub my back. "Erin, we need to get you in to see a surgeon as soon as possible. You have some very concerning films here, and I am 99 percent sure that you have breast cancer. This needs to be followed up with a biopsy and a consult with a general surgeon." He proceeded to write some more directions on a piece of paper that I was to take with me, directions that he said

would help me remember what I needed to do first. He would be setting everything up for me, but it was now past closing time, and he was waiting to give me my films to take along to my appointments.

Perhaps it was the mascara running down my face that caused the girls in the hall to stop and hug me. They even walked me to my truck. When the door closed, I just laid my head against the steering wheel and wept. "How can this be? I prayed, Lord. I had friends praying. You said it would be okay. What did I do to cause this?" Nothing. Just the same, sweet peace.

I made the necessary call to Aaron. That sounds better than saying that I was actually hysterical as I repeated what the doctor had said. He was nearby and decided that we would meet at Applebee's. Pulling out of the drive of the doctor's office, I called my mom and dad. Somehow you never have the right words to convey bad news. I can only imagine what they must have been thinking. It shouldn't be like this. Surely there must be some mistake. Other people's reactions were as varied as a menu. There was a little bit of everything. Belief, disbelief, fear, anger, sorrow, shock, etc.

Time has a way of flying by when you are having fun. Not only does the "tick" sound loud when you are waiting to leave for your vacation, but it literally slows down to slow motion, picture by picture, when you are desperate to cling to every minute you have. You don't want it to end. It suddenly becomes more precious than anything and you don't want to miss a thing. I didn't either.

I began looking for a miracle, any miracle—even in the mammograms. Anything. It would be a long time

before I would see that the miracle WAS in the mammogram. I had much to learn. I still do. In a way I was able to see the "last chapter" or rather, what "would happen" as I was waiting in the ultrasound room. You know, "in whom to trust." The journey was just getting started, and yes, you could say that it had my full attention.

Laughter and Butterflies

Chapter 3

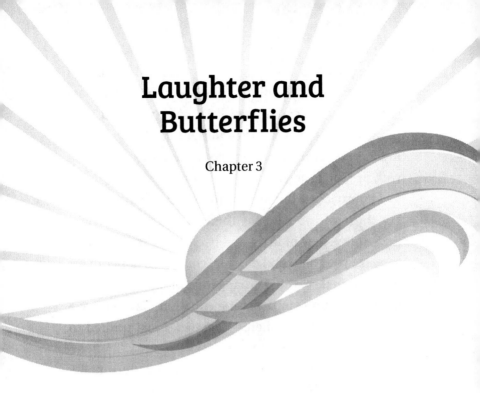

"I will call upon the Lord, who is worthy to be praised; so shall I be saved from my enemies." (Psalm 18:3 NKJV).

As I mentioned earlier, music is in our blood. Not just in mine, but in my husband Aaron's and my little boy Cade's soul as well. We both led worship prior to getting married, so it was a natural transition when we continued to do so at our church.

Each year, our worship team is asked to go to a local facility for troubled teens. Christmas can be such a difficult time of year for them, spending it in a less than desirable way. No family nearby. No presents. No hope, for most of them. We are honored to go, and each year come away more blessed than the time before. This particular year we were each going to give a five-minute testimony.

The past two weeks had been crazy. How could I share a testimony? I didn't know what to say. We were supposed to be spreading Christmas cheer, and I certainly wasn't going to throw rain on their parade with my "news." All I could think about was EMMANUEL. God with us. God is here.

I approached the microphone and began to shake. For those of you who say there are all sorts of tricks that work—they didn't. I had been given the advice to squeeze your hind end or your "cheeks" together to get over the shakes. Fail. Perhaps imagining the audience being in a more embarrassing situation than you have ever been in, would help? Negative. I just wanted to laugh. And laugh some more.

Laughter has always been a part of my personality. I have the unfortunate sense of humor that laughs at things that others find completely serious. It's a disorder for sure. I believe Inappropriate Laughing Disorder would come close. I can think of a half dozen things right now that could set me to slapping my leg and tears to come pouring from my eyes. Mercy. I don't know if many would call it a blessing; perhaps it is more like a curse. For example, when somebody falls . . . I just can't help it. I am readily available to help them up, but I don't know what comes over me. If you ever fall around me, just know that my motives are pure. I am not laughing AT you; it is something called "black humor."

This was NOT a laughing situation, but was getting there quickly for me. Nerves coupled with raw emotion had set me on edge. I just wanted my turn to be over. I began to share with the kids that I had recently been

diagnosed with cancer, and had received the biopsy report the evening before.

Do you ever wonder what it would have been like for Mary and Joseph? Approaching Christmas, my mind continually wanders to what life would have looked like for them. A virgin about to give birth. Crowds of people everywhere. The smell of a barn as aromatherapy. No warm blankets to bring comfort. A very nervous Joseph, waiting, believing, maybe even doubting that he had heard from the Lord. I can imagine Joseph and Mary did not have a Christmas like they expected either.

Our nativity set rests on a chest or even under the tree from the moment the tree is up. Cade loves to play "Christmas" with it. He handed me the pieces of Jesus and the manger while he was playing and said, "Mom, watch these two for me. They are important and cannot get lost." How appropriate and absolutely true. As the doctor called me and told me the news, I remember falling to the floor and dry heaving as soon as I hung up. I don't remember much of the conversation, but I do recall him asking me if there was something he could do for me. In response I asked him "to get it all." His recommendation was a double mastectomy. Soon. As in, less than a week. He canceled his Christmas travel plans and scheduled my surgery. He didn't want to wait, and neither did we.

What little I knew, I continued to tell the kids. Many of them didn't have the hope of Jesus in their hearts, and as depressing as I knew this could be for them, I wanted to give them hope. I prayed, and the Lord answered. I shared with them about Emmanuel. I knew

Him. I believe in Him as the hope of Christmas. I told them that I was taking Him with me into surgery, and I was confident that I would be back again next year, cancer free, and proving to them that the Lord CAN take you through the valley, but He is more than able to bring you back out through your deepest darkness and make you whole. Better than before. It boils down to this truth; His will—His way.

A short time after we concluded, a young man who had recently received Christ in his heart came up to me and told me that he had a nickname to give me: "Mariposa," Spanish for butterfly (I had to ask him to translate). I asked him why he chose that, and his response was, "I didn't. The Lord gave it to me on my heart while you were sharing. I believe that a butterfly flies free and overcomes anything and everything." Wow! I was getting chills by now, because just that morning, I had received a package from my mom. In it she had sent three ornaments for our tree. Butterflies. Yellow, orange, and green.

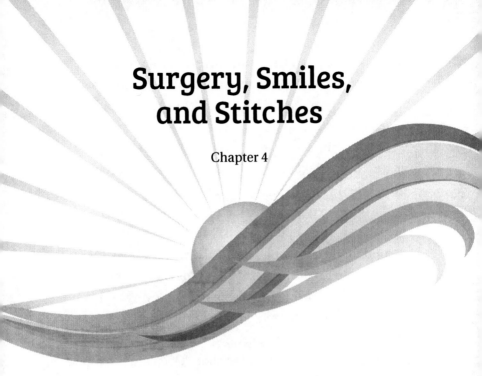

Surgery, Smiles, and Stitches

Chapter 4

"A friend loves at all times, and a brother is born for adversity" (Proverbs 17:17).

My sister, Alison (aka: Ali-wish-ous), and I share the same sense of humor. When we were teenagers, we would try to slap at each other and if we "accidentally" hit one of our breasts, we would say out loud, "Pray for swelling." It never worked. I am not sure that the Lord really listens to "mature" prayers such as those, but rather rolls His eyes and wonders why we spend our time the way we do and say the things we say. Yes, we were (and are) blessed with abundance. Well, abundant laughter instead of "other things." We made up for our lack with wit, wisdom, and a desire to laugh at the days to come as written about in Proverbs 31:25: "She is clothed with

strength and dignity; she can laugh at the days to come." (We are still working on the strength and dignity part, not to mention maturity . . . but let us make that our special secret.)

Beyond our slapping extravaganzas my sister and I share a deep, solid friendship, one that stands the test of time. When I called her with my news, she immediately broke down in tears and said, "It's okay; we are going to fight this thing together . . . you WILL overcome this." The second to the last word became the word of hope that I would cling to for the next year of my life. Sisters have the blessing (like few friendships do) of loving and hating you, but in a moment's notice, dropping everything to be anything that you need.

She sent me the link to the song "Overcome" by Jon Egan, and to another one called "Shout Unto God" by Michael W. Smith. They became a battle march for the nights leading up to surgery and for many months after.

The morning of surgery dawned, and while it was still dark, Alison and I were up doing what we do best by being silly. We snapped a few photos, teased about me getting to walk into the hospital in my PJs, and just tried to avoid the issue. Don't you love that about your besties? You can be distracted by anything they say and it works, because in our time of need we all become proficient at living beyond ourselves and truly giving whatever we can for the needs of others.

Cade had gone to my wonderful friend Rachelle's house. Aaron had the day off of work. Mom, Dad, Alison, and my brother Adam were all there with me. Friends dropped by the hospital to pray, to wait, to visit. All of us

with the same thought in the back of our minds: "Please, God . . . let this be contained. Let the doctors get it all. Oh Healer, heal."

Dr. Eason walked in and shook his head at me. He asked me why I was all dressed up. Let me just clarify something. There is NO possible way to look "dressed up" in a hospital gown. The gown plays peek-a-boo with everyone you come into contact with and you simply cannot help it. The ties don't tie. They feel starched and scratchy, and smell like a combination of bleach and "stinky smell." My particular gown was the same as everyone else's: floral, puke-colored floral with some ivy décor. Yes, I blended in perfectly with wallpaper. Very flattering! His comment made me laugh. You see, I had very long hair (at the time) and had gotten up that morning and put it in curlers. I didn't know how to show the Lord that I had faith that He was going to show up and work a miracle, so I did the best thing that I knew how to do, and decided to physically look the best that I could look for Him when He showed up to do a miracle on my body, through the hands of the surgeon. The enemy has been defeated. Death couldn't hold Jesus down. And this same Jesus was with me now. Emmanuel.

I am assuming that was what the doctor was referring to when he saw me not my designer gown. It came as no surprise that he thought I had lost my mind when I began to tell him what my mission was. I told him that he was made for such a time as this. He smiled and said, "Okay, let's go. I feel better when HE is on my side."

Television shows that convey the drama depicted in an operating room, or waiting room leave out the

emotions that you feel on the inside. When my family and friends came back to visit me, there was so much I wanted to say but couldn't get past the lump in my throat. I couldn't even see them for all the tears. A million words, I could say anything, but I didn't. I said nothing. Just hugged them and told them all I loved them. Inside I felt like I was dying. Scared, freezing cold, and wondering how in the world was I going to wake up and handle seeing myself without breasts. I had faith, but oh, so little for such a mountain that stood before me.

The "drive" to the operating room was lengthy. Remember the butterflies? Well, just before they switched me to the operating table in the OR, I looked over, and on the wall was a mural. Trees, water, beautiful green grass, blue skies, and yes . . . butterflies. I asked the nurse if I was hallucinating, and he assured me he hadn't given me anything yet. As I lay back on my new resting place, I looked over, and on one of the nurse's shirts was printed boldly: BELIEVE. I closed my eyes, and did just that . . . believing.

Prior to going into surgery, you usually have a few things to do to prepare for the big day—blood work, EKG, talking with an anesthesiologist, give them allergy info, etc. I was pretty nervous about this because several years ago, while I was pregnant with Cade, I underwent another surgery to remove a benign cyst that had attached itself to the uterus. It is rare, but if not taken out during the "window" of opportunity, it could eventually have killed the baby or myself. This tumor would find the food supply and grow faster than the baby. It had

begun to do that and had grown from the size of a grape when they found it to the size of a grapefruit in just two short weeks. Needless to say, after THAT surgery, when I awoke from my drug-induced slumber, I could hear myself confessing my undying love to: MY GYNECOLOGIST. Believing he was Aaron, but not being able to pull my eyelids open, I was so thankful to be coming awake after surgery. When I opened my eyes and realized what I had said and to WHOM I had said it, well, lets just say my mortification was acute. To this day he hasn't let me forget that. We have a special "bond," and when he sees me he will, on occaision, greet me with "Hellloooo! And so we meet again." You can now imagine my concern. How many doctors could I love?

Thankfully, I had a nurse wake me up. Well, let me take that back. I believe I had an angel watching over me. As she said my name, I distinctly remember her putting her face to mine and telling me, "It is okay. The Lord is here. The Lord is with you." Emmanuel. Opening my eyes, I saw her name tag. "Donna" was printed in bold. She had on green scrubs, sort of curly hair, and she smelled so sweet . . . just like my friend Marsha. So much so that I was sure it was her.

Marsha was a registered nurse who went to my home church growing up. She would encourage me and would snap pictures EVERY chance she got. Her son TJ and I had birthdays close together, and her daughter Lindsay and I were good friends. Shortly before my diagnosis, Marsha went home to be with the Lord at a young age, a beautiful woman who really lived her life. Through many heartaches and pains she bravely marched on. Every year she

gave me a birthday card filled with confetti and gum. I sent her one back a month before she passed, because I was thinking of her that day. I had run across a picture of me, turning thirteen, braces, awkward, but Marsha had taken it. There was another when I had cut my hair short, weeks after giving birth, and had the worst haircut of my life. She snapped that one as well and told me that it would be priceless one day. She was right, because it is. Not only for the people in the picture, though precious, but because of who took it.

Whether it was her or not, I will never know, that is up to the Lord, but the comfort I found in Donna's embrace was like no other. I woke up crying. My pillow was soaked. The nurses around me said that occasionally I would let out a gutteral sigh, as if holding back a deep, deep grief. They were spot on. My first tangible thought was, "I don't want to wake up. I don't want to die, but where do you go from here? My whole world changed, and I can't do a darned thing about it. I want to be mad. I am sad. I am tired of crying. I don't want to lose my hair. I don't even want to be here. Why, Lord? Where are you?"

Emmanuel . . . God with us.

My friend Lisa was able to be close by that day, being a nurse. She was working the Oncology floor. She was such a blessing and a help to me. One of the many nurses that brought me up to my room that day went back to the recovery area and found that there was no one by the name of Donna that worked on the floor that day. I had asked her to go and see if I could thank her for encouraging me. Not one person with that name was on the list of workers that day. Nor did anyone see a woman

in green scrubs, as they only wear blue around the surgery floor. Wow.

Aaron and I were able to see her earlier. She had even gone out to the waiting room and brought him to see me while I was waking up. After that, she was gone. We never saw where she went, and apparently no one else did either. Seeing her the brief time that we did, well, I guess that is all that matters. He was there, and He did show up. The Lord was letting us know that He was there. Sweet, silent, but ever present, Emmanuel.

Bondage or Bandage

Chapter 5

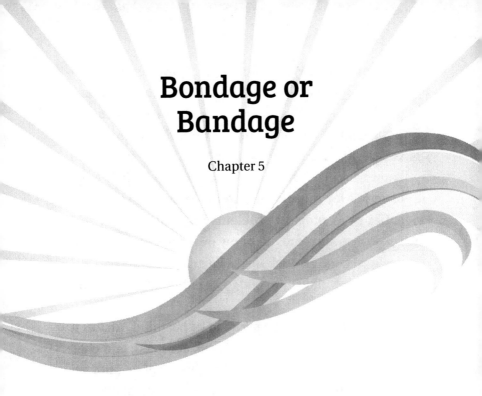

*"For God is greater than our hearts,
and he knows everything"*
(1 John 3:20b).

What makes a girl self-conscious? Good grief! That is a question of the ages! It could be anything. Everything. Depending on the time of the day (or month). As life moves on, you begin to reflect on why you are the way you are. Good times, and bad. My responsibility, or theirs. Those that desire to grow, keep pressing on, regardless of the pain. We all reflect on decisions, friendships, successes, or even failures. It is what we do with these thoughts that is pivptol for us.

As a young girl, I had struggles like most kids. We fought against the fact that we couldn't be "just like

everyone else." We wanted to be. However, we home-schooled—when it wasn't cool. We milked and drank goat's milk—when others discovered the convenience of "bottled milk." We even drove the proverbial homeschool vehicle: a van, only ours was the "mini" version. And you know what? We survived. Not one of us is socially inept or in jail for murder, and to my knowledge we don't suffer psychological problems because of it. My self-conscousness came out of my own sin, out of my own decisions that I myself made. Were my parents perfect? No, but they didn't pretend to be either. They lived and let us live.

Each one of us has a desire to be beautiful. We feel it is our God-given right to be loved, accepted, and cherished. That works wonderfully for most of us until we are about three years old and have our toys taken from us. We quickly learn that the world is a big place and has the potential to hurt.

Subconsciously, I was making decisions to be everything everyone else wanted me to be, because I had a people-pleasing nature. A lot of mercy was mixed in there as well, but not enough wisdom to know how and when to apply the said mercy. This began setting the stage for me and my thought process: "I have to be the good girl. I have to help out and not feel bad about doing it. I need to accept people for their bad behavior, even if it hurts me, because that is what a good Christian is supposed to do, right?" These types of thoughts continued and eventually grew to more and more and more, to where I just wouldn't deal with them anymore. If I confronted those around me, they would hate me, right?

I just couldn't handle that. My people-pleasing identity would be lost! I wouldn't know who I was if I wasn't defined by others.

Life with Jesus has a way of bringing things out of the woodwork. Especially when it comes to matters of the heart. You see, the Lord loves us just as we are. Unconditionally. No exceptions. Yet He loves us too much to leave us where we are at.

As an adult I started working on these unhealthy thoughts and surrendering them to the Lord. One by one, brick by brick, the wall started coming down, the wall that I had so carefully built around my heart so no one could see the real me. The reason behind it was that so I wouldn't get hurt. Let me just clarify: THIS IS NOT A GOOD PLACE TO BE.

From the very beginning of man, back to the original sin—it wasn't the apple that separated us from God. It was our desire to be independent of Him. Remember my brick wall? It becomes built up by using lie upon lie. Not dealing with things appropriately. Unforgiveness. Bitterness. The inability to give or receive love because of lies, lies, and more lies that we have believed.

Friends came and went, visiting me in the hospital. I cannot recall the room number or the number of times per hour that they checked on me. I didn't have much pain. Numbness under my arms and some discomfort, but not a lot of pain. The doctors had stressed the importance of taking the meds by the clock instead of by my pain, due to the nature of the surgery. Nerves had been cut. Tendons had been moved. Parts that were, were no more.

When I got up for the first time on my own, I made it to the bathroom and had to pull the "help" cord. You know the one—bright red, makes a loud alarm sound. It was difficult to have to need help with even the very basics, like going to the bathroom, showering, and dressing myself. Frustrating. Embarrassing. Humbling.

I didn't watch much television. I did like the Nature Channel with the sweet music. No words, just hymns and praise songs, arranged in a soothing, peaceful, and hopeful melody. Sometimes words and hugs go only so far. Those songs went into the crevices of my heart where no one else could go. The Holy Spirit worked His way in loosing the bondage of past hurts, unforgiveness, and destructive thoughts, beginning in that hospital room.

Flowers and cards arrived hourly for the first day. I was released the second day, Christmas Eve. It wasn't a wonder to me when Aaron walked into the hospital room that morning, just as the bandages were being removed. It was Emmanuel—God was with me. Showing me a physical miracle—work that He was doing. I looked down and I wept. I would never be able to feel the warmth of my sweet boy's face on my bosom as I hugged him. Never again would I be able to nurse a child and know the satisfaction and rightness of providing something that God put in place. Seeing myself physically as so many of us are spiritually: barren, broken, and in need of a Savior—brought me to my knees. God wasn't done with me yet. I knew it and could see it even through the tears. But it was at that very moment the final brick came down, and I was introduced to "me,"

myself, for the very first time. With nothing to hide behind and nothing to hide, my Healer began to rebuild me from the ground up, and I have never been the same.

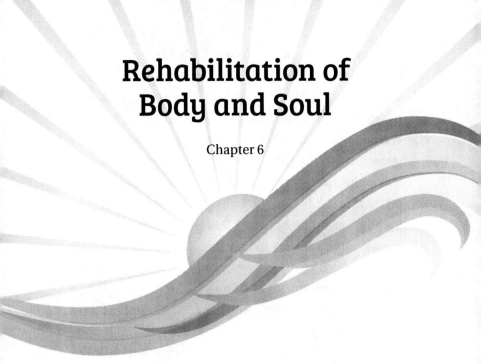

Rehabilitation of Body and Soul

Chapter 6

"Life isn't about waiting for the storm to pass . . . It's about learning to dance in the rain." —Vivian Greene

M y family members were able to stay for a couple of days after I returned home to help me around the house. I was on every kind of restriction you can imagine: driving, lifting, hugging, all the while dealing with my new temporary friends called Drains. I had two of them, coming out from under each arm. Their purpose was to prevent the empty spaces from filling with fluid that could potentially become infected.

Many have asked why I did what is considered "radical" and had BOTH of my breasts removed. To answer a popular question, I was given a series of statistics. When you are handed a diagnosis of any kind of cancer, you

want to know numbers. To put it plainly—you want to know who lives and dies and the only thing they can show you is numbers based on stats. I had met with my oncologist in the hospital AFTER surgery. The same is true for my radiologist, primary care physician, and gynecologist. The main physicians I spoke with up until this point, were my general surgeon and the radiologist that had handled the biopsy. That was their recommendation. To be honest, I had personally decided in the days following my biopsy that if the tests came back positive, both of my breasts would be removed. There were too many stories of "If only . . ."or "They only had one removed . . . and it came back." The numbers were too convincing for me.

What many people may not know is that lymph nodes are removed if there is any suspicion that there may be cancer involved in them. AND that just because you have lymph node involvement does not make it a "bad" thing. Part of the lymph node's job is to be a filter. Cancer cells tend to be larger, and though they grow rapidly, they are also more difficult to slip through a "strainer," if you will. At the time, I panicked. Great, I thought, if this is in my lymphs, then I am a goner. Where else has it spread to? Why didn't I go the first day I felt sore under my arm after my cold? Etc. . . .

In the weeks following my surgery, I was given a pamplet full of exercises that I was to do. To look at them now, I almost laugh because they seem so easy. I was completely drenched in sweat and breathless when I began doing just the first series of movements. It was weeks later that I was actually able to accomplish them without

immediately taking a nap after I was finished. Not only did the exercises drain my energy, but my balance was off as well. I never considered that possibility before! I didn't really understand what "lack" was until I truly had nothing. I had to learn to compensate for the loss of my breasts as I did simple things. Bending, stretching, running up the stairs, etc.

Healing came day by day physically. It was the same for me spiritually. At first I was looking, reading, calling, and researching any story that sounded like mine so I could "rest assured" or ease my own worry. Perhaps I would be able to ask them questions of what their experience held so I could learn from them.

My drains came out almost two and one-half weeks after surgery. I was getting stronger, and my incisions were healing nicely. I went ahead and had another out-patient surgery for a chemotherapy port, that was placed in my right shoulder, underneath my collarbone. That surgery was painful! Dr. Eason told me to expect a frog-like feeling, like the kind you give people in the leg. No, it was more accurately a knifelike feeling only in the shoulder. The pain was probably magnified due to the other recent surgery. Regardless . . . hope for the best or expect the worst.

In the week or two that followed, I was shuttled to and from my oncologist and back to the hospital for more tests. I was able to get a PET Scan, checking to see if there was any more cancer in my body. The scan came back completely normal, without a trace of cancer. Also, I had to participate in several scans and tests of my heart to see if I was strong enough for chemotherapy.

Everyone knows what it is like to face disappointment of some kind. Perhaps you didn't get the job you just knew was a "sure bet," or perhaps your spouse decided they didn't want to be married anymore. These, among the thousands of other roadblocks that come our way, often shape us into who we are today. For better or for worse, they are there in our past. I have always felt that the only reason you need to look back, is if you are going to move forward. Looking back without moving forward would leave us stuck right in the muddy, murky waters of yuckiness. At least that is what it would do for me.

As I said earlier, I had finally come face-to-face with myself and realized that in order to move forward, I needed to do some looking back. I am not proud of some of the things that I have done in my life. Yet at the same time, there are definite moments in my life that were building blocks of hope, moving my life in the direction that the Lord was leading me. His Word says in Philippians 1:6 "he who began a good work in you will carry it on to completion until the day of Christ Jesus." If the Lord was at work in my life during my past, then I had to learn to trust Him for the here and now, plus the future as well. This was going to take some work, some consistent rehabilitation of my heart, body, and soul. I had some major roadblocks that He began to uncover, hidden deep within my heart. Pride and fear were the first He began to tear away at, and I never saw it coming until I was bald . . .

Finding True Beauty amidst the Fairy Tales

Chapter 7

"Charm is deceptive, and beauty is fleeting; but a woman who fears the Lord is to be praised" (Proverbs 31:30).

"The sacrifices of God are a broken spirit; a broken and contrite heart, O God, you will not despise" (Psalm 51:17).

Have you ever had one of those dreams where you were out somewhere very public, and suddenly you realized that you had little or no clothes on? Let's be honest: whether we will admit it or not, we probably have. Do you remember how you felt? Embarrassed! Horrified! It was like everything was in slow motion . . . scratch that—everything you did was in slow motion, while everyone else looked normal. Even your voice was rrrreeeeaaaallllllyyyy ssssslllloooowwwww. You just

couldn't wake up from this dream. The solution usually ends up being something ridiculous, like somehow you were able to find a sheet or some bread bags and you sewed them together (forget that there is no reasonable answer as to how you got the needle, thread, AND the talent to sew in the first place), and everything just started to work out. At least I hope it did for your sake. And mine.

Nightmares are never fun. Real-life ones aren't either. They are worse because they are true. You are still embarrassed and horrified. You still have no reasonable thought process most of the time and few people will understand where you are at. Oh how easily and quickly we judge what we would do if we were in "so and so's" position. Why? Because in a way we are trying to reason out why this would never happen to us. That by doing this and thus you would never be in this position, or would choose to do this or that to your body. It is always easy when it isn't you. But when it is, how I wish there were an easy answer or an "easy" button to push for all of us. Each one of us will find ourselves in a situation at some time in our lives involving some major crisis completely out of our control, and then we will be forced to make some decisions that impact our life or that of a loved one's—forever.

It happened one night as I was putting Cade to bed. He is five and still loves to have his mommy read to him, snuggle, and say prayers as a bedtime routine. I wouldn't give it up for the world. Only on rare occasions does he want his daddy to fill in. I assume that will happen more often as he grows, but for now I am content to fill the position. "Mommy," he whispered, "are you going to die?"

I don't know about you, but I have a "super-mom" mask that I wear when I want to scream—but cannot. When I want to hurt someone or something—but you refrain. When I need an answer—and I make it up. I tried to pull out my mask right then and there, but the silly thing went missing on me. I decided that honesty was the best policy, and that the masks were overrated.

He began to cry, and I joined him. Truth, being always on the side of time, brings light and healing when carefully tended, as if it were a precious plant you grow in your flowerbeds. Aaron and I had committed Cade to the Lord when he was born and promised to teach him in the way that he should go, following Jesus: The Way, the Truth, and the Life (John 14:6).

Fairy tales always make it look better. Why was Cinderella in the situation she was in? Or Snow White? They make you feel good with thoughts of happily ever after, but are never a step-by-step guide dealing with the real issues.

"Cade, Mommy has something in her body that you cannot see. It is a sickness called cancer. Yes, it can cause people to die, but we don't know if Mommy is going to die from this or not. You need to know that life and death are in the hands of the Lord, and you know what? Everyone will die someday, but that isn't the end for those who know Jesus. He thinks it is precious when one of His own comes back to Him (Psalm 116:15). I am not ready to go, but I don't have the final say. I believe with my whole heart that the Lord took all the cancer out of my body during surgery. The rest is up to Him."

Cade has a way with words. If you have ever read my

blog or my Facebook posts, you will understand perhaps why the Lord blessed me with one child. He is all I can handle, and all I want to handle. It has taken me many years to understand why sometimes we need to be thankful for unanswered prayers. We don't even know ourselves half the time, so why do we pretend to think we know what we really need? Well, it just so happened that after the time had come to tell Cade, being the bright young man that he is, he knew something more was up than just what I had told him. He was pretty disturbed to see that the hospital had taken some of Mommy's "parts" and hadn't given them back. He also asked me how I got it and somehow became convinced it was because I didn't wear enough deodorant. Not only would the world smell a little better, but wouldn't it be awesome if it were so easy? Perhaps we are the ones that make it difficult, just a thought.

Chemotherapy began with infusions every other week for eight weeks. Every day, even the weekends, I was to go to the hospital for shots (in the stomach) to boost my white blood cell count. The medicine that I was given was called Epirubicen and Cytoxin, a cocktail of sorts that is "lovingly" called the Red Devil. Multiple combinations have that nickname, and share in the same dreaded color. Finishing this course, I would follow it with twelve, weekly infusions of Taxol. Yes, it was a lot. These are powerful drugs, but without them, many don't live. As for the side effects? Nerve pain, bone pain, weight gain or loss, dry mouth, loss of taste and hair loss ten to fourteen days after the first dose. Those side effects were rudely interrupting my happily ever after.

It was nine and one-half days after my first dose. I had gone to see my hairdresser two weeks prior and had her give me a short, chin-length cut. Going from long hair to chin-length was a shock, but good. Something different for a change. From chin-length to baldness was devastating.

Aaron had come home from work, only to find me in tears. "It's happening. My hair is coming out and I cannot stop it. Please, just make it stop!" He kind of chuckled. Of course I knew this would happen, but experiencing the balding process was totally different. I wasn't mad at him, just the situation. I resolved that one way or another it was going to come out. Better sooner than later, and I certainly didn't want to be picking up hair every day like I was doing right then. It was messy. Stringy. Sometimes it was clumps, and other times just a few strands at a time. Aaron pulled out the clippers and said, "Baby, let's just shave it off. I'm not a hairdresser, but since it ALL has to come off, I can't mess it up too bad."

Where was the white horse? Wasn't it just one kiss that awoke Snow White from slumber? Here was my prince charming, willing to kiss me, but dressed in work clothes armed with a pair of hair trimmers. What?!

It was freezing cold outside. February, if I recall correctly. The first stroke of the trimmers left me swinging at him. It hurt—badly! He realized that we were going to have to go about this differently, and by this time we were both laughing. When you cry so much, you just get tired of it. The only thing left to do is, well, laugh! He got a pair of scissors and went to town on my head. He was cracking himself up and asked me to go take a look at

myself, only to stop me and say, "Never mind . . . don't. You will see it soon enough." I knew he was hurting inside too. (Insert a punching-the-wind motion.)

I looked like Demi Moore in G.I. Jane. For real. Only I had several "patches" that were just completely bald. No hair. Cade was sleeping, but woke up just as we finished. When he saw me he ran and found a place to hide. I knew the feeling. He cried, but then was excited, because we told him that being bald meant that Mommy's medicine/treatments were working. They were doing their job. We may have bribed him with ice cream, candy, AND a raise in his allowance if he would come and sit on my lap so I didn't feel so badly. Things get a little foggy from there . . .

At the hospital it was dealing with no breasts. Here at home in the mirror I realized that the physical parts that make a woman "attractive" were no more for me at least for now. Sure, the hair would come back, and I would be reconstructed, but for the time being I was sitting . . . at rock bottom. Even my sweet little boy didn't want to be around Mommy.

The fierce pride was gone—at least most of it. I really didn't want people to see me like this. Looking for a shred of dignity and finding none in my humanness, I started to see myself through spiritual eyes. My true heart's condition. Barren, bald, and now broken. The amazing part of grace, is that it is totally undeserved, unmerited favor. One hundred percent pure love, given freely, poured out on all who come.

Through the mirror I was able to see that I wasn't ugly in Jesus' eyes. He knew this would happen. I believe

that everything is sifted through His hands before it even reaches our lives. Does it seem unfair? Perhaps, but where would we be without believing in His Sovereign control? Without His ever-present, all-knowing, all-sufficient and supreme Self? We would be left right where I was, at rock bottom. The only difference would be: no hope.

Miracles were happening all around me. My own fairy tale was being written as I was acting things out, trying to be obedient, submitted to the Lord's will, and often fighting my way there each day, and sometime minute by minute. What was I learning through all of this?

"Mirror, mirror, on the wall, who's the fairest one of all?"

"Erin Leigh Shafer—a Jesus girl, made in the image and likeness of her King. Born for such a time as this." We are beautiful because of Jesus, not these momentary "clothes" we have on. He showed me through my own reflection in that mirror that you don't need breasts and hair to be loved. You are loved just the way you are. NO mastectomy or body part that is lost for some reason or another, whether seen or unseen, makes you less of a woman. Or a man for that matter.

Do you hear that sound? No, that isn't the sound of shattering glass breaking because you looked into the mirror. That is the loud clanging of metal gates. When you embrace this truth that you are loved for you . . . the gates of hell begin to shake. Grab hold of this truth, girls, and let the gates shake until they rattle off of their hinges. "They overcame him by the blood of the Lamb and the word of their testimony" (Revelation 12:11). Shout it LOUD! YOU ARE LOVED!

You can take Him at His word. He is a refuge (Psalm 46:1) and our shield (Proverbs 30:5). And by the way, tell the devil to go to hell, back to where he came from. This Cinderella is learning to dance with both shoes on. Death couldn't hold Him in the grave, and it wasn't going to stop the work He was doing in His girl's life. Yes, this girl was coming clean. Even cleaner than Snow White herself.

To Say or Not to Say . . .

Chapter 8

"May these words of my mouth and this meditation of my heart be pleasing in you sight, LORD, my Rock and my Redeemer" (Psalm 19:14).

I have always said from the beginning of this journey, that I would write a book, or at least a chapter on what NOT to say to someone with cancer. I am going to put out a disclaimer. Some of you may not share my same "black" sense of humor. I apologize right up front. Some of you may seriously wonder what not to say to people with cancer. I have included some helpful tips. Remember, this is just one girl's opinion. Not all are the same.

Several months after my bilateral mastectomies, I had to go be fitted for prosthetic breasts. Yes, there truly is such a thing. I decided to take Rachelle, a best

friend of mine, along so she could help me decide on a comfortable size. If you have never gone to such a place that specializes in such things, you would be right where I was that day. I had no idea there was a place, let alone provision for women like me. The women that owned the place and worked there were kindness itself. I found myself thinking, "What a strange job. Necessary, but odd."

The mother of this mother/daughter owned shop took me back to a room and began fitting me with bras. Empty bras. Imagine if you will a woman with a completely bare and scarred chest, looking at herself in the mirror with these empty bras. To add to my dismay, she nearly drowned me in embarrassment when she held out my hand and literally threw this triangular-looking thing into my palm, and encouraged me to "give it a squeeze" (insert "mortification").

Let's just get something straight. I have never said the word "breast" so many times in my life as I have throughout the course of this journey. Besides saying the word, I have most definitely NEVER gone around squeezing another woman's breast. That is exactly what it felt like. Awkward. And wrong. Very wrong.

Rachelle kept encouraging me try on bigger, just for the anyhow. The fact that you could take them on and off in seconds didn't hurt. Plus, by this time, I was already scarlet from embarrassment and laughing at anything and everything. Nerves and embarrassment will do that to you! The "mother" was encouraging me to stay away from looking like Dolly Parton. Seriously? Can't you humor a bare-chested woman, and at least let her try it on?

For the first time in my life, I wasn't a washboard! AND I didn't have to pray for swelling!

After laughs, measurements, and choices, I made my purchase and wore them happily home. Here's the funny part. Not only were they expensive—three hundred dollars . . . per SIDE—but she measured me incorrectly around the chest. Let's just say they sagged lower than my spirits that day. They don't take any returns, so I have had to make several adjustments and voila . . . no one knows.

No one knows until one day, you lose one.

Had I know that prosthetics had a wandering spirit, I would have stapled them down. At least tied them down inside their bra. How in the world do you wear certain blouses with just one side installed?

I came up with a great idea . . . well, maybe a not-so-great idea, but one that had Aaron and I in tears, we were laughing so hard.

Sunday mornings were hard for me. I sing with Aaron on the worship team at church and play the piano. Today was just a singing day, which for me meant that I would be turning his pages and helping him lead. Great. I had to find something decent to wear. I didn't need a "breast cancer awareness" outfit, nor did I need a lopsided look. (I still couldn't find the darned thing!) I decided to pull out my old bra and just stuff it with socks. What could it hurt?

All went well until I let go of the back straps, just after fastening it down tight. If you can imagine a slingshot letting go of a rock, you wouldn't be far off. The two pairs of socks shot straight out, faster than the speed of light.

The bra itself settled right around my neck. Don't try it at home. It doesn't work. Not when you don't have "weight" holding it down.

I found the wandering breast later on in the week as I was cleaning. It had bounced off and rolled under my bed. For the love of Pete! Those things are just overrated! Take it from me—leave the improvising to the professionals.

Many of my laughs have come over the subject of wigs. I mentioned before that Aaron and I sing, and on one particular morning I was helping him lead worship when he reached up to raise his hand in praise and caught his guitar pick in my hair. The whole wig tilted. Seriously, I think I made the front rows consider a rededication or a first-time decision for Christ.

Our church has a lot of wonderfully talented people. One of them happens to be my good friend, Raelene. Raelene and I have done a lot of skits, dramas, and singing together, particularly for VBS, Easter, and Christmas. Raelene has an amazing skill of writing meaningful, worshipful, and insightful plays that reflect Jesus in a multitude of ways.

It was just before Christmas, just before my surgery. Chemotherapy was five short weeks away. Christmas was just days away. We had a huge drama, in which I played the mother of a little girl and the wife of a man who was forever changed after hearing the Word of God and reading slips of paper on which the Word of God was written. It was a successful evening. Everything happened according to plan and after the play we lined up to receive guests and greet newcomers.

I was standing by the back of the sanctuary when a young man I have never met came up to me and said (and I quote), "I heard you have cancer; that sucks. My grandmother had it too and she died. Good luck to you." And as he turned away, he came back and offered his dead grandmother's wigs to me, if I'd like them.

I was speechless.

This was from a woman: "Well it is a good thing you have some extra weight to spare. I heard that chemotherapy really takes it out of you and leaves you looking pretty scrawny OR really fat." If I wondered what it would be like, I wondered no more. I have such pleasant pictures dancing in my head of a bald and now scrawny / morbidly obese woman!

From a young lady, "Do you think that reconstruction is spiritual?"

From another well-intentioned gentleman, "You are welcome to my mom and grandmother's wigs. They don't need them anymore. They died." (What is with the wigs of the deceased?)

Another woman approached me with this one, "My best friend went to a WONDERFUL oncologist. If you like, I could get the name for you."

ME: "Oh, that is so nice, thank you. How is your friend doing?"

HER: "Well, she died last month."

ME: "Oh, no! I am so sorry to hear that."
 To myself: "I think I will find another doctor."

The last one took the cake for me. Seriously, this one still has me laughing about it. After you read it, you will understand. This took place about mid-chemo treatments . . .

(Phone ringing)

ME: "Hello?"

CALLER: "Erin?"

ME: "Yes?"

CALLER: "Just calling to confirm your 2:30 p.m. appointment for laser hair removal on Saturday?"

ME: "Really? Are you sure you have the right Erin?"

CALLER: "Yes, ma'am. You called us on Thursday to schedule your armpit hair removal and we are just calling to confirm."

ME: "I am sorry, ma'am, but I am sure you have the wrong Erin. I don't even have hair (any hair) at the moment, because I am in the middle of chemotherapy." (Insert the snorting/laugh that comes when it is surpressed and inappropriate. Plus Miss Conneticut Phone Call is still NOT listening to or understanding what I am trying to tell her.)

CALLER: "Is your number: ###-###-####?"

ME: "Yes, but I live hours away . . ."
(interrupted)

CALLER: "And is your name Erin Markillie?"

ME: "No, it's . . ." (interrupted, again)

CALLER: "And don't you live on . . . OH! ("pregnant pause") It's not?"

ME: "No."

(Her realization is starting to dawn as she is trying to repeat all I said to her back to herself. Only she doesn't whisper . . . she speaks into the earpiece.)

CALLER: "Oh, oh . . . I am so sorry."

ME: "Don't be, you just gave me a great laugh!"

CALLER: "Ma'am, I am so sorry. I hope you get better. I—"

ME: "No worries. I just don't think I will be able to make my appointment on Saturday!"

I got off the phone and laughed until I cried! What are the chances that an Erin would have a hair removal appointment somewhere in Connecticut, when I am another Erin who has no hair and lives in Missouri, yet is the one gets the "reminder call"?

Some days you just have to laugh, when you spend a good deal of time crying through every phase.

For those who have asked about the less obvious things of "what not to say", here are some pointers.

"I'm jealous of your time off doing anything."

» SUGGESTION: "Hey, I am looking forward to spending some time with you when you are feeling up to it."

Hope, people. Keep it positive and please, give us some hope.

"Well, look at the bright side; you only have two more chemo treatments to go!"

» SUGGESTION: "Is there something I can do for you to help out these next couple of weeks? I am rejoicing with you as you approach this big milestone! What would you like to do to celebrate?"

Don't make it sound like all we are is a downer. After all—how would you feel if the shoe was on your foot?

"Look at you! You'll at least get to look eighty-five with a twenty-five-year-old chest!"

» SUGGESTION: "You look beautiful. Better than ever!"

There is precious little that has remained the same. The last thing that most women want to be reminded of is the "new normal" that they cannot change. They had no choice about in the first place. Keep it simple and keep it encouraging. Don't throw in opinions or facts with what you

think to be true. No one story is the same. Some may not make it to eighty-five. Others may not have the option to reconstruct. Still others will never go into remission even after chemo is done. It is a grave reality for these women. For me, our times are in the Lord's hands. Treat us the same way. Gentle. Loving. And don't look away. We are still ourselves, just a little battle scarred.

A good rule of thumb is this: If you don't know what to say, don't say anything. A hug says immeasurably more:

"I care."

"I love you and I am so sorry you are going through this."

"I am here for you."

"I am touching you because you are not contagious. You are my friend, and I still see you in there!"

"Don't lose yourself in this."

There will be varied opinions about what to say and what not to say. If in doubt, hug. Chances are it has been awhile since they have felt that.

Desperate Times Call for Desperate Measures

Chapter 9

*"My mamma always said life was like a box of chocolates.
You never know what you're gonna get" (Forrest Gump).*

Forrest Gump knew a lot more than just about running. Sometimes the things we learn in life are the things we were told when we were little. It just takes longer to sink in, and many times it takes experience for us to "get it."

With the unknown always before us, how then do we really *live* again after something so traumatic? How are we supposed to just pick up the pieces and start again with a new normal when we liked the old one just fine?

I remember one morning, waking up and looking at Aaron and just feeling the need to beg him not to trade me in. You know, like on a "new" wife. One who was

whole. Perhaps one with a little less body weight. One who could have more children. Perhaps one who could handle situations and stuff like this better than I was.

I was angry.

I was grieving.

I was desperate.

The day had started off just like any other day. I had appointments—nothing new there. I was waiting to hear back from the doctor regarding some lab results—been there before. I am not sure what triggered it, but somewhere along the trail of today I found myself spiraling out of control.

Have you ever been there? You know, like when you get weighed in at the doctor's office, and you are so mad at the number on the scale that you kick the wall and send an expletive through the air. I have only heard of this happening—to a friend, of course.

Disappointments come in every shape and size. Like it or not, we all have them. Hurting people hurt people. When folks are disappointed in life, it is going to come out. Sometimes in the least expected ways . . . like grief.

Grief has many phases. The cycles rotate around and around. True progress is made when we see less and less of the emotional response coming out of us as we cycle through yet another phase, and see our spirit respond with the wisdom we digested that comes only from God's Word.

I didn't want to be where I was. I certainly didn't want to turn thirty and have to have a bilateral mastectomy. I know of folks who voluntarily do them for their own reasons. I commend them. For me? I was struggling with

the fact that I wasn't given a choice. I wasn't asked. I had lost control, and I still didn't like it.

Almost a year had passed. I still felt the same way. Control is never easy to lose. The funny thing is that we never had it to begin with. We only thought we did.

As I wrote this, I was two weeks away from surgery: *"A total hysterectomy. To have this voluntarily would be one thing. To 'have to have' it is another, at least for me. For some reason I am struggling with the fact that I will not be able to have any more children."* The thought almost makes me laugh because I had a very rough pregnancy while carrying Cade, and Aaron and I had decided to adopt any more children, even before we were married.

So what was the problem?

Control.

I cannot control these things. I certainly didn't want to have to have the frequent ultrasounds, blood tests, and biopsies that were recommended if I didn't have this done. And I certainly didn't want to deal with worrying month to month, wondering if another cancer would pop up in that area due to the nature of hormone cancers.

Ever since I was a little girl, I had dreams of adopting. Foreign, domestic, it really didn't matter to me. I was determined to adopt. Aaron was the same way. We both knew what we wanted to do, and a short time after Cade was one year old, we began our long journey toward adoption.

To save you a long story, I will simply tell you that the Lord closed the door on every single situation that was given us. Korea? Closed. Private adoption (eight total)?

Find another way. State adoption? Stalemate. Each of these situations spelled loss, and loss of control.

We were at a complete loss as to where to go and what to do. Isn't that exactly where we all find ourselves when our life is changing and we are less than excited about it? We found our solace in some wisdom from the Psalms . . .

"Thy word is a lamp unto my feet, and a light unto my path" (Psalm 119:105 King James Version).

The comfort from those words on days like today seems far away. I want to see the big picture. Remember how I like to read the last chapter of a book? I needed stadium lights right here and now, but the truth is, the Lord knows just what I need, when I need it. Especially on days like today.

So how was this supposed to be "normal"? How was I just supposed to begin again after piecing together the fragments of my loss of control mixed with my broken heart?

TRUST. One step at a time. One day, every minute, every trial . . . trust. Rest in His sovereignty. Bask in His ability to see the big picture, and fully rely on His strength to see it to completion. What a lot to absorb! However, grabbing hold of this truth allowed me to have a lifesaver thrown into the messy, murky pool of my life. To begin to glue each piece of the puzzle together.

"He satisfies the thirsty and fills the hungry with good things" (Psalm 107:9). Growing pains. Challenges. Various Trials. Victories. Each one represents a new set of wisdom needed.

Scripture says, "Taste and see that the Lord is good; blessed is the man who takes refuge in him" (Psalm 34:8).

I was tasting and choosing to live apart from His goodness. My heart's condition was getting desperate. We all know what that calls for. The desperate measures that I needed to take were found in David's plea. The desperate cry for mercy, forgiveness, and cleansing.

"Against you, you only, have I sinned . . . Surely you desire truth in the inner parts; you teach me wisdom in the inmost place . . . Create in me a pure heart, O God, and renew a steadfast spirit within me . . . Restore to me the joy of your salvation and grant me a willing spirit, to sustain me" (Psalm 51:4a,6,10,12).

"For the Lord God is a sun and shield; the Lord bestows favor and honor; no good thing does he withhold from those whose walk is blameless. O Lord Almighty, blessed is the man who trusts in you" (Psalm 84:11–12).

Chocolate always makes me thirsty and hungry for more. It is so good that there are even times I just can't get enough. The same should be said of my heart toward Jesus. He is good. He is our shield and a refuge. Whether we need a shield or a refuge, He is everything we need.

When we attack these desperate hearts of ours, we cannot be deceived by the smooth, savory goodness of self-pity or denial. That is kind of like putting imitation chocolate in our mouths. Our appetites need to develop a craving for the things of God. The goodness of Him. The desire to be with Him.

He is everything to us, exactly when we need Him. And yes, we definitely need Him. We cannot control a thing in our life except our choice to follow Him. To honor Him. To trust Him. He alone satisfies our desires with the richness of His presence and with good things.

When we go through these trials, He allows them for our good. He alone can see the big picture. Hold fast to Him. To His truth. To His sovereign control.

And by the way . . . remember the doctor's office scenario from "a friend"? Yes, that was me. I am ashamed to admit it, but in a way it is freeing also. I am sure I looked pretty desperate at the doctor's office when I went on about my business like nothing ever happened. I have a lot to learn . . . and I am learning a lot. Desperate measures need to be taken in my walk with the Lord. For now, I am learning to trust Him in everything . . . because "you never know what you're gonna get."

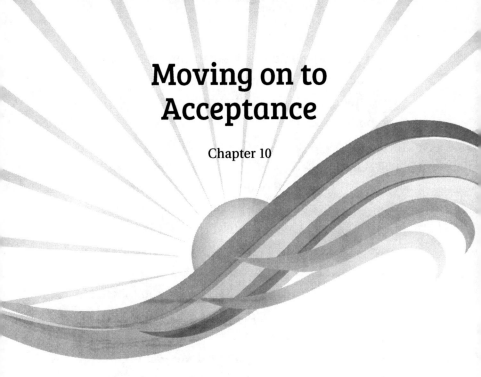

Moving on to Acceptance

Chapter 10

*"As the mountains surround Jerusalem, so the Lord
surrounds his people both now and forevermore"
(Psalm 125: 2).*

Over and over again, I have found myself mulling over
the concept of acceptance. Such a tough, tough
word. From what I have found, it travels closely with
coping.

To cope, according to Webster's, is to "contend with
difficulties with the intention of overcoming them." The
meaning of acceptance is "the act of taking or receiving
something offered."

Do you see the relationship between the two words?

It's powerful, isn't it? When we begin to fully under-
stand, when we realize that sometimes we have to

accept the unacceptable, we can then begin to rise above our circumstances. Accepting the things that we cannot change. That is the making of a person who overcomes.

I love the thought of someone overcoming. One of my biggest struggles through this whole journey has been dealing with the issue of death. Isn't everyone afraid of dying? Or someone they love dying? Such a big and scary word. Unknown. Lonely. I don't like it still, but one day I turned and faced it.

Why didn't I like to think about dying?

I have always loved Psalm 91. I love finding shelter in the wings of the Most High. I love the thought of finding refuge in Him. His protection all around me and knowing He will deliver me. One day as I was reading, I came across a verse in the chapter before this one. Psalm 90. Look at verse 12 with me:

"Teach us to number our days aright, that we may gain a heart of wisdom."

As my curious nature is, I had to dig a little deeper. Were there any more verses like this one?

" 'Show me, O LORD, my life's end and the number of my days; let me know how fleeting is my life' " (Psalm 39:4).

Accepting isn't "liking" what we were given. Take another look at the meaning of the word acceptance—"The act of taking or receiving something offered." I don't see the words "liking it" or "loving it" anywhere around. When

we take something, we usually end up doing something with it.

Could this be our answer? That we are actually supposed to do something with the trials of life that we don't necessarily ask for, but end up with? Could this be why we are encouraged in scripture to number and count our days? To realize just how fleeting life is?

It isn't about death at all. We know that ten out of ten people die. It is one of life's guarantees this side of Eden. It is learning to cope and accept this fact that perhaps sidetracks us from learning to live. It isn't about dreading the end, but perhaps dying before we accomplished what we know in our heart of hearts was our purpose for being here in the first place.

The passion and gifts that drive us, the unfulfilled dreams—all of it would be over if we died. But if we are worried about death, are we really living then? Is it the fear of dying or fear of failure that keeps us back from really living? Failure would come in to play if at the end of our lives we found ourselves having done nothing or not completing things we wanted to do, because we never tried. We only feared death because we didn't want to live without these dreams coming into reality, and instead hid behind our fears.

No one ever learned how to read overnight. We weren't born with the knowledge of how to walk. It took time and time again of landing on our rears and brushing off the bruise-tinted knees to fully enjoy the pleasure of trying and trying again until we one day took a few steps. Those led to more until we became strong enough to run. Skip. Jump. Live.

Could this be where we see the relationship between the two words collide?

"Contend with difficulties with the intention of overcoming them."

Once we accept our situation, it is only then that we can do something about it. To make something good come out of this. Only it isn't us. Not in our own strength.

Consider it pure joy, my brothers, whenever you face trials of many kinds, because you know that the testing of your faith develops perseverance. Perseverance must finish its work so that you may be mature and complete, not lacking anything. (James 1:2–4)

His divine power has given us everything we need for life and godliness through our knowledge of him who called us by his own glory and goodness.

For this very reason, make every effort to add to your faith goodness; and to goodness, knowledge; and to knowledge, self-control; and to self-control, perseverance; and to perseverance, godliness; and to godliness, brotherly kindness; and to brotherly kindness, love. For if you possess these qualities in increasing measure, they will keep you from being ineffective and unproductive in your knowledge of our Lord Jesus Christ.

For if you do these things, you will never fail. (2 Peter 1:3,5–8,10b)

Did you see the similarity between the two scriptures?
Perseverance.

"Steady persistence in a course of action, a purpose, state, etc., especially in spite of difficulties, obstacles, or discouragement," (Webster).

Our parents or loved ones helped us back up time and time again before we learned to run. Until we actually "got it." They picked us up, brushed us off, and said, "You're getting it! Come on! Try again!"

I can almost hear the Lord crying out to us in much the same way as we go through the trials of this life. Yes, death is certain, but God sees it as something completely different. "Precious in the sight of the Lord is the death of his saints" (Psalm 116:15). Did you see that? PRECIOUS. Finish out the chapter with me:

O Lord, truly I am your servant; I am your servant, the son of your maidservant; you have freed me from my chains.

I will sacrifice a thank offering to you and call on the name of the Lord. I will fulfill my vows to the Lord in the presence of all his people, in the courts of the house of the Lord—in your midst, O Jerusalem.

Praise the Lord. (Psalm 116:16–19).

Maybe I am stretching this as I read it. But just perhaps, because of the freedom in knowing Christ, and the assurance of knowing that the Lord sees death as sure as the dawn, but precious as well . . . notice the life of the

psalmist? He makes a choice to praise. To live. To fulfill the vows he has made. Beloved, so should we.

Here is something I wrote out while going through all of this. It is based on the meanings of the words as outlined above, and includes several of the scripture references as well.

I will take what I am given and in spite of the difficulties,
Obstacles or discouragement that I face:
I WILL overcome
Through Jesus.
I will persevere through the power in the blood of the Lamb
Who has freed me from the bondage of my sin.
I have been given everything I need for living in godliness
Even during this season.
I choose to glorify him. I will choose today to PRAISE Him.
I will continue to walk in confidence because with Jesus,
I will NEVER walk alone. He cares and He knows.
He will not waste
this season of my life. As I turn and face my fears of death
and dying
I will praise. I will worship. I know where I am going,
but until I am called there, I will learn to LIVE. Breathe.
I will choose to not
fear because with Jesus I will NEVER fail.

And my friend, neither will you.

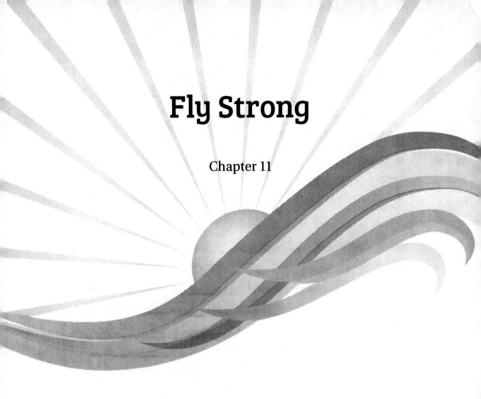

Fly Strong

Chapter 11

"For I know the plans I have for you,"
declares the Lord, "plans to prosper you and not to
harm you, plans to give you hope and a future"
(Jeremiah 29:11).

One of the most difficult questions I have been asked along this journey has been, "Why did God catch your cancer early and not my own?" Oh, how my heart just breaks. I literally go home and sob after I talk to these people who have lost or are losing a loved one. Or the person is dying themselves.

I wish I had an answer.

I don't know.

Many times when I say this, people look at me like I have a third eye, or as if they want to hurt me. I understand.

I really do. I'm walking this road too. It looks different from all angles.

I understand sleepless nights. I have tasted real fear. I have answered dreaded questions. I have had a diagnosis. But I don't hold the future in my hands. No one does. Except Jesus.

Recently I had a conversation with a woman who was angry. She had cancer. Was in the middle of fighting (what was for her) a losing battle. Angry for all that she was leaving behind. Angry for all that she hadn't done yet. Angry because she didn't want to die. She began pumping me with questions. I am a survivor, and there is just something about having lived "through it" that makes you want to talk to other survivors or victims and compare stories. Sort of hash things out. Reason things out. All of it is really us just trying to make sense out of it.

I didn't have answers for her. She didn't like my non-answers. She didn't like my story. I know. I didn't like hers either. However, I talked with her and shared with her about Jesus. It was the only thing I knew to do. She was a believer, but was out of hope.

Sort of like what I pictured John the Baptist being before he was beheaded.

After Jesus had finished instructing his twelve disciples, he went on from there to teach and preach in the towns of Galilee.

When John heard in prison what Christ was doing, he sent his disciples to ask him, "Are you the one who was to come, or should we expect someone else?"

Jesus replied, "Go back and report to John what you hear and see: The blind receive sight, the lame walk, those who have leprosy are cured, the deaf hear, the dead are raised, and the good news is preached to the poor. Blessed is the man who does not fall away on account of me." (Matthew 11:1–6)

John's disciples told him about all these things. Calling two of them, he sent them to the Lord to ask, "Are you the one who was to come, or should we expect someone else?"

When the men came to Jesus, they said, "John the Baptist sent us to you to ask, 'Are you the one, or should we expect someone else?'"

At that very time Jesus cured many who had diseases, sicknesses and evil spirits, and gave sight to many who were blind. So he replied to the messengers, "Go back and report to John what you have seen and heard: The blind receive sight, the lame walk, those who have leprosy are cured, the deaf hear, the dead are raised, and the good news is preached to the poor. Blessed is the man who does not fall away on account of me. (Luke 7:18–23)

Remember, at this point, Jesus and John the Baptist have already had an interaction when Jesus went to John to be baptized. My Life Application Study Bible Commentary stated that "he (Jesus) was identifying with the penitent people of God, not with the critical Pharisees who were only watching. Jesus, the perfect man, didn't

need baptism for sin, but he accepted baptism in obedient service to the Father, and God showed his approval."

Powerful, isn't it? John doubted. In his time of need he was reaching out to see, in essence, if Jesus was who He said He was. Perhaps he thought, "Tell me, please, just tell me the truth—has everything I have been working for all this time been for nothing? Are you truly the 'Lamb of God who takes away the sin of the world'?" (John 1:29)

I remember being at that same point when I first learned of my cancer diagnosis. Curled up in the fetal position on my living room floor, I begged the Lord to reveal Himself to me. "Are You who You say You are? Are You in this? Is there purpose in this happening to me?" My sweet little boy came in from the other room and laid across my body with his and cried. I wept harder. "Why, Lord? Are You listening?"

He showed up. He taught me.

Moment by moment. Fear by fear. He never left.

Let us throw off everything that hinders and the sin that so easily entangles, and let us run with perseverance the race marked out for us. Let us fix our eyes on Jesus, the author and perfecter of our faith, who for the joy set before him endured the cross, scorning its shame, and sat down at the right hand of the throne of God. Consider him who endured such opposition . . . so that you will not grow weary and lose heart. (Hebrews 12: 1–3)

To the woman for whom I had no answer, I want to share this comforting thought . . .

"Fix your eyes on Jesus . . . so that you will not grow weary and lose heart."

We all are running a race. Running toward the prize. Our goal? To glorify Jesus. If you find yourself running through the finish ribbon or the checkered flag—don't give up. Finish well, my friend. Finish strong. We are all right behind you.

Every runner is running to the finish line. We are simply at different paces and distances from our own finish ribbon and checkered flag.

While speaking at a women's retreat, a woman wrote me a little note and stuck it in my bag, down by my chair. I found it when I returned home. The note read: "Fly Strong." Immediately I was reminded of the dear, sweet woman. Regardless of our circumstances, I truly believe we are to not only continue to praise, but LIVE. Fight with everything you have to LIVE, so that when you finish, you and everyone bearing witness to your walk can say with confidence, "You finished well, my friend." The finish is certain, but how well we run is up to us.

I want to do more than just live strong. I want to thrive. Flying strong means thriving. Thriving means overcoming. Overcoming means thriving to me. Living.

I am still running, friends. You are still running as well. Run strong. Run hard. He is worth it. He truly is "the Lamb of God, who takes away the sin of the world" (John 1:29).

And in case you are wondering . . . He wins in the end. Someday soon there will be no more sadness, tears, sickness, or disappointments. We will then truly and freely learn how to fly strong. It's a win-win situation!

Raptured or Ruptured?

Chapter 12

"Indeed, if you call out for insight and cry aloud for understanding, and if you look for it as silver and search for it as hidden treasure, then you will understand the fear of the Lord and find the knowledge of God. For the Lord gives wisdom; from his mouth come knowledge and understanding" (Proverbs 2:3–6).

In an earlier chapter, I talked about the time that a young woman asked me whether or not implants were scriptural.

Huh? There are times where I am truly without words.

Cancer is not scriptural, but how do you explain that to every person afflicted? There's a good question that needs answers! Believe me, I am WAY underqualified. Please remember, I am a simple woman who sees life

through the eyes of a redeemed sinner. Myself. I have asked very stupid questions before myself. I have stood on a soapbox of self-righteousness and declared things I HAD NO RIGHT to.

Believe me when I tell you . . . learn from these mistakes of mine. Others' as well. You don't "know" how it is until you have been there.

If you have ever been to a plastic surgeon for reconstruction, you know just how vulnerable you feel. He sits on a chair and you stand in front of him. (Just writing this sounds dirty.) There is nothing dirty about it. He simply does this to measure where your breasts used to be. He writes down exact numbers as to the length and depth of your scars, your hollow chest cavities. After this, he hands you a book filled with pictures of his work. You guessed it . . . breasts.

By now my face is totally red. I mean, this is worse than the prosthetics place! It totally feels wrong, but he isn't doing anything. There is nothing there. Besides that, there are three other women in the room at the same time. Weird. Awkwardness at its best, not to mention uncomfortable. Completely.

Anyhow, before and after pictures are taken, and before you know it, your appointment is over, and you leave feeling totally violated, but almost ridiculous too, because this is just as much a part of the treatment process as the chemo and radiation were.

We as women always have a weird sense of humor when it comes to that part of our body. As we grow we feel like our bodies have revolted, and we struggle through each growing phase and just have to accept it.

Guys will never understand.

Either way, I am sure there are struggles that they have and that we don't see. For those that we do, we make amends for. We joke it off. For others, we just don't even go there. Are you with me?

I would give anything at times to go back to where I was. It isn't fun learning all of this stuff, plus dealing with all the loss. Sometimes my mind feels so full I am almost dizzy. Besides, this is from the girl who used to slap her sister and "pray for swelling." I had pictures in my mind as to how I would look once the reconstruction phase was complete. The beautifully reconstructed new me.

For those who are wondering how I answered the young lady? I simply responded to her by saying that if my implants don't get caught up with me in the rapture (if the Lord takes me home that way), but end up splattered in a ruptured puddle along with my clothes for heavens sake—she missed it! Don't stress over the details and miss Jesus.

Sadly, she was more concerned about something that had absolutely no heavenly value and was trying to place guilt on me where it didn't belong. She was missing the fact that she would be standing there watching to see if they raptured, ruptured, or bounced along down the street instead of being caught up with me.

My first thought going to my surgeon was that I would be self-conscious standing before the Lord like this: bare, scarred, ashamed. But my second one trumped the first: *I will be whole one day.* In body, soul, mind, and spirit. We all will. Whatever scars we bear will be healed because of Jesus. Praise the Lord!

So if you see me in heaven, praising the Lord in my new body . . . join in the dance, my friend. It will be so much fun, and we can go on forever.

And if you only see my scars, you too have missed it. Who cares if they are ruptured or raptured? We all have scars. Some are just more obvious than others. They tell a story of a Kinsman Redeemer who is working all things to His glory. Don't stand ashamed. He calls us out. To dance. To sing. He loves you just the way you are. And if you get to heaven and the implants have ruptured, let Him tell the story. It's all His anyways.

Reconstruction

Chapter 13

"He who was seated on the throne said, "I am making everything new!" Then he said, "Write this down, for these words are trustworthy and true" (Revelation 21:5)

Ahh . . . The moment has arrived! Finally, the question that everyone (or so it seems) wants to know. This question has been the most often asked: "So, how are things going with the reconstruction? What size did you end up?"

My best friend recently had a heart-to-heart conversation with me. Not in the usual way, but in the way that really brings some things to light. Lovingly, I might add.

During a coveted coffee-conversation, she leaned over and said, "Erin, don't lose yourself in your own story. You are so much more than breast cancer . . ."

One might imagine that a person like me who is void of estrogen would be lacking emotion as well. My recent landscaping project would probably give credence to their assumption. Mixed with a wild arrangement and little to no symmetry, my project is complete. Almost. Did you know that there are four sides to a house? I love it. Much to my man's dismay!

Emotions run much deeper than estrogen and aren't measured by vials of life-flowing blood or even the sweat energy that we put into a project. They are often tested and molded by life-giving or life-taking experiences.

Such is life.

The beautiful with the scandalous.

The tattered with the new.

The powerful insight of a friend, and the gentle, soothing words of another. All three bound tightly with the mystery of life.

While processing my BFF's words, several things happened. Realization dawned anew as I began unfolding her quiet, loving words. They hurt. They spoke volumes. They also gave me freedom. Freedom to remember that yes, I can write again. After a hiatus of not writing, which only she knew about, she could see that I was beginning to withdraw into myself and feel bound by boundaries that others, along with myself, were trying to put me into.

Now, hear me well. I do NOT believe in the blame game, but rather in personal responsibility. There are things we knowingly put ourselves into. Yet there are also times that we seldom realize when another person's words or expectations have become the measuring cup of our success or even our self-worth. Realizing

the difference sometimes requires the intervention of another.

My friend knew me before, during, and after cancer. While we share a different personality, she is one who is gifted with insight and wisdom. Wisdom that knows when to speak and when to listen. Insight that knows when to intervene and when to refrain. I love that about her.

As I mentioned, the most common of questions is about reconstruction. Believe it or not, most people feel more comfortable talking about that with me than they do even about their own children! One would imagine that someone such as myself would openly share about this part of the experience with joy and some enlighten-ment . . . au contraire!

Our bodies have an amazing ability to heal them-selves. When they cannot, modern medicine and inter-vention are needed. But the end goal of both is the same . . . healing. Much like my friends words, healing can take on many forms.

"So, what size are you going to be when you are done?"

"Aren't you about done now? You know, you have to consider that you are on a stage of sorts being in the ministry and what is your real motive behind wanting to be bigger than you were?"

"How is your breast health?"

"Do they really have to tattoo your nipples on?"

"Can you even feel them anymore? I mean with your scars and all . . ."

"I bet you are excited to actually have an option of size now, right?"

"Will you let us feel them when you are done?"

Sometimes before healing can take place, the hands of a knowing physician must lance the poison that lay below the surface. Most, if not all of these questions have the same "opening up" effect on me. The closer to feeling back to normal I get, the more invasive these questions become. I don't mind them coming from close friends, but casual acquaintances and complete strangers—it seems a bit inappropriate.

Think about it like this. What if I came up to you and asked if I could feel your breasts because I forgot what "real" ones felt like. What if I suggested that you go see a plastics guy because I felt like you were too small. How is YOUR breast health? What do your nipples look like?

Please hear me well. I am NOT poking fun here, simply showing you just how invasive and probing these questions feel. Inappropriate at best. Be kind. As much as we enjoy sharing about what we have experienced, I have yet to meet a woman who is willing to give complimentary show and feels to curious observers. Respect the natural boundaries that were in place before this began. Don't put another sister, mother, daughter, or wife through needless rude inquiries unless you are SURE that she would be okay with that. I am, most of the time, but not from everyone. Especially men.

I fight with the fact that I even had to go through all of this. I hear people tell me often to "give yourself a break"

when the words of well-intentioned people probe you out of your newly constructed self. How do you even give yourself a break, when you feel criticized even in the healing process?

The Lord has worked a powerful, painful surgery on my heart in this area. There are not a lot of funny stories to share regarding this part of me deep down. He has a way of getting to the heart of the matter in His way and His timing.

Vulnerable doesn't begin to describe it. Torn apart and left alone to pick up the pieces is more like it. Only I am not alone. I have the Spirit, who is even now interceding for me with words, because even just writing this feels like another invasive question. Yet I write for healing, and for those that are in it now, and who will come after me (sadly enough) to know that you are not alone. I have friends who know me and love me still. I have my husband who has shown Christlike love for his wife-partner-helpmate.

The battle is fierce, my friends.

There is a reason that 85 percent of marital relationships end after a breast cancer diagnosis. I am not a physician, nor an expert in this area. Just a survivor turned thriver in this spaghetti-type mess called cancer. And I am still crawling my way out of this.

We have had our struggles, and like you and many others, we will continue. It is what makes marriage a beautiful covenant instead of just beautifully written words hastily repeated so that the party can begin. The party of marriage is this life. The ebb and flow of ups and downs. You win some, you lose some. You cause some,

you deflect some. You learn to forgive, and forgive again. You grow, and you keep moving on.

I would love to sit here and give you a powerful weapon to use against those that hurt you, whether stranger or friend, but I can't. Self-pity is too big a hole and takes too strong a hold on us. Don't believe the lies and fall into the pit of despair. And please, don't become a victim in your own story. You, too, are so much more than cancer. Perhaps, like me, it took cancer for you to awaken into the full realization that you are made for a purpose larger than a free radical cell turned deadly.

Cancer is just a word, not a sentence. Realizing this truth can have the same aggressive growth pattern on our soul and can be life altering. People said silly things before cancer. Cancer has just fine-tuned your feelings on life.

Yes, cancer takes a lot. It can take a life. It can bring new life. You can lose your hair in the healing stage. It makes you gain and/or lose weight. It changes your hormones, your physical appearance, and possibly alters the way that someone feels about you. That is NOT who you are.

Many nights I have cried myself to sleep over something I never thought much about. If I wanted to lose weight, I would diet. If I wanted my hair a different color, I would dye it. If I wanted a new outfit, I would buy it. All of that changed. It is still changing.

Like the lance in the surgeon's hands, the painful lesson of discipline sets in. I have met and passed many people on this road I am on, finding so many who have given up. I know. For a time I did too. I still want to. Yet

I am determined to overcome. I am determined to live fully. Not just as a survivor, but as Erin—a daughter of the Most High King, who has learned through this struggle that she is more than a diagnosis. She was created to live life fully, to glorify her heavenly Father, and if this is going to bring His glory more fully into focus for herself and others, then may He alone be praised. May my life be about living what my name means: PEACE. In every area.

As I mentioned above, discipline of thoughts. Reconstructing them, if you will. Replacing the old lies, with new truths. Truths that set you free, not limiting you to one word.

I have had to learn some new things along the way. Words of truth that are difficult to swallow because I didn't ask for cancer in the first place. Now to fight the old self-pity thoughts with the new words of truth. These moments of sadness allow for me to learn a new and life giving truth.

As for weight gain: I have been working with a trainer to carefully learn about and hopefully avoid lymphedema, while reshaping and strengthening my body. I would be a liar to sit here and say I didn't want to be back to where I was. I do, but I also want to be even better. It is and will be difficult to lose weight, but not impossible. A lot has changed. I cannot go back, so I move forward with that new knowledge. I have to do things differently, but it still works. It will work. Time is the best healer, and in time I will get there.

And eating: I am learning that due to treatment, I am at high risk for type 2 diabetes. I am currently embracing

a lower carb, low sugar lifestyle. Old habits die hard, people. I will always love ketchup. Perhaps when they are tattooing, I can have them write a few loving words to honor my love of the sweet and salty goodness.

Taking each day at a time, I am learning that if I exercise and watch my diet, that is physically all I can do. The math will play out in time. Time has its own way of healing.

My marriage? Looking forward to a lifetime of "for betters" and thankful for the lessons we are learning in the "for worse."

And as for the whole reconstruction process? Yes, you will know what size I end up at. Obviously. *Smile.* Physically, it is painful. Probably the most painful portion of recovery. Emotionally, this has been good for me. Yes, healing.

My prayer is that regardless of where you choose to focus your attention or your critique, you will see that the real work accomplished was in my reconstructed heart. Lord willing, my body is stronger and healing; my eating habits are edifying to my body and to what the Lord is doing in me; and my lifestyle reflects the reconstruction that has taken place in my heart. And for better and because of the worse, that PEACE reigns in my heart, soul, and mind. Perhaps making this life just that much better for you, for me, and for all those that come after.

"For Better or for Worse . . ."

Chapter 14

"I'm gonna love you forever. Forever and ever, amen."
—Randy Travis

I have sat through, and more often than not, have participated in my share of weddings. They all end successfully, and for the most part, just as planned. Most love stories sound almost identical at least in their most basic form: Girl meets guy, they fall in love, become engaged, plan for a wedding, and live happily ever after . . . Right? Isn't that how it is supposed to be?

Once you are married, I cannot tell you exactly when it happens, but suddenly you realize that the honeymoon is over. You have mixed emotions because you knew it was coming, but you also long to move into a deeper season. More mature love. Yes, still loving your mate, but

something more than just a surface excitement.

Every newlywed couple never plans to "literally" live out your vows. Let me take that back . . . we make these vows with the best of intentions. We marry based on an idea that "marriage is what we make it." So, with that thought on the forefront of our minds, we race ahead in life determined to overlook "for worse" and "for poorer" and "in sickness," because health, wealth, and the better, fit with the "happily ever after" mentality. We just never think that all those other things will actually happen to us.

When hardships come, most people tend to overspiritualize things, and look for the reasons and the elusive question: Why? How come? Is this God's will for me? Like marriage, we often tend to make situations about us: selfish.

During the early days after diagnosis I remember my Doctor telling me that 85 percent of marriages don't make it through a breast cancer diagnosis. I could hardly believe it! My knight in shining armor and I were great! We had a good marriage. A solid marriage. We could and would weather this storm, wouldn't we? Couldn't we? We were Christians after all . . . didn't that count for something?

There was no doubt in my mind, or in Aaron's for that matter, that we were in this for the long haul, but here is where I am going to be brutally honest with you: marriage is more than sex. It has to be. The foundation of any relationship has to be built on Jesus Christ and Him only . . . then friendship, trust, strengthened by faith, and held together by love. There should be nothing selfish about marriage.

All of that sounds great until you have to live it. Putting feet to our faith is often the hardest step to take as Christians. The place where the rubber meets the road is much better lived out in other's lives, and we would much rather be a "guide" than a lead-by-example person. Guys, Aaron is going to share a chapter later on in this book. Hang in there . . .

Most people don't realize that intimacy is almost nonexistent during treatment. The change your body undergoes makes it just that much more difficult. Add to that fact that there are the physical parts that were mutually enjoyed which are no longer present—just ugly, red scars. Don't forget that your body is now in medically induced menopause . . . good grief!

"For better or for worse" came to my mind as I stared at my scars across my chest and my hairless head and my now plumper body. Sex just didn't even enter my mind as I gazed at my reflection. At this point it was simply a three-letter word in Webster's Dictionary, catalogued alphabetically.

After the initial surgeries, it was months before I would even let my husband see my body. I was so ashamed, and I didn't know why. I was embarrassed and mad that I had to go through this, yet was very insecure as to where to go from here. What was the next step? Questions began entering my mind. Doubts threatened to overflow my former confidence in my man.

Would he still love me? Would he reject me? Would he still see me as his bride, handpicked for him? Would he remember the "for better" in our vows instead of this season of "for worse"? Would he still want to honor those

vows we made seven years ago? I sure hoped so, because that seemed to me to be the only thread holding us together. There seemed to be so many vulnerable and difficult questions that had little to no answers. Fear seemed to exaggerate everything out of proportion.

There isn't a delicate way to put this other than to say that things were "awkward" for us at first. I could see him struggling with his own reactions and emotions. I was desperately trying to come to grips with mine. I had changed both outside and on the inside. That much was obvious. I could see his disappointment. Sense his frustration and couldn't do a darned thing about it. Not one.

Lingerie wouldn't stay up. Bras require some weight to stay on, no not on my hips (I had plenty of that), but on my chest. How could I feel sexy, let alone look sexy like this? I didn't even know if I felt feminine.

Magazines, commercials, and models became a weapon the enemy used to try to destroy my self-esteem and image—an image that we ought to remember was fashioned in my mother's womb. I, (yes, even me) was formed in the image of my Creator. His view of me never changed. It never will. The Lord was starting to move into the deepest part of who I believed I was, and was separating the lies from the truth.

In those early days we did the only thing we could think of . . . we laughed. We worked our way through each step. Believe me when I say those were some dark days for us. We cried and we rejoiced that perhaps the winter wouldn't be as "cold" as Aaron originally thought! When we couldn't see anything funny to laugh at, we found something to give us hope and a smile.

Laughing has a way of setting us free—free from our own worries, and providing coping skills for the worries that are unavoidable. It becomes its own language that mediates between the wants and can't haves in this life. Laughter is relaxing and such a blessed relief!

I once heard that "A faith that hasn't been tested can't be trusted" (Adrian Rogers). That is true in relationships too. They MUST be tested. If they are going to stand, they must be made out of more than physical pleasure. When that is gone or on "temporary leave," you are still married, still committed, and still together. What would you have left if you made your marriage out of only the physical? Marriage is something that takes time, but needs the proper conditions to grow into a healthy, lifelong love story.

Take for instance an Oak Tree.

An oak tree is slow growing, but when full grown, is one of the most beautiful trees. It is just as big underground as it is aboveground. We cannot see the beauty of the whole tree, just the outer and upper parts. How does it grow so big? By the deep, strong roots forced down into the ground by the wind and storms of this life.

If a gardener puts a stake into the ground, it is most often a temporary fix to straighten a tree to grow in the right direction. How I would love to stay "strapped to the stake," but if I did, I would never experience the freedom of having no strings attached. Neither would my marriage. This deeper season for us was one of growth, maturing, and learning to trust on a deeper level with the "for worse" of this life.

And as for Aaron? He learned to laugh right along with

me through every part of this. Creativity stretched us both, and if we were honest—the promise of a new body helps us considerably. Naturally you miss what you don't have any more, but we recognized what we did have was and is precious, and we wouldn't trade it for anything. If you asked either one of us if we would do it all over again, even knowing what lay ahead . . . both of us would. No strings attached. For better or for worse.

Forever and ever, amen.

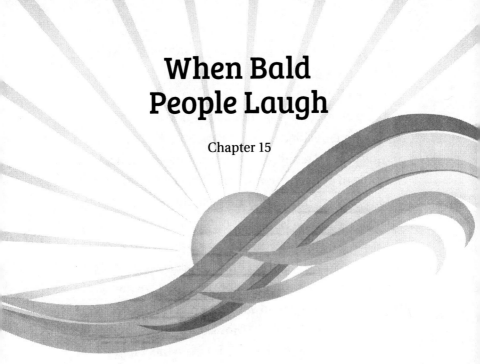

When Bald People Laugh

Chapter 15

"He will once again fill your mouth with laughter and your lips with shouts of joy" (Job 8:21).

My little boy has a way about him, and he says some pretty outrageous things. He comes up with some great one-liners about his personal observations, life, and just plain silliness out of nowhere! He is hilarious.

When he began kindergarten, I signed up to be room mom assistant. Part of my job was showing up to the parties, help with bringing snacks, decorating, well—you get the picture. I started noticing one day while at the Thanksgiving party that I was receiving some strange looks from the little kids.

Having eight in the class has to be a blessing for any teacher, but mercy, the mess they can be! I wonder if the

Lord ever has those thoughts about us? What a mess . . . but there is a part of me that likes to think that he gets quite a kick out of us as well.

As I was mentioning the looks I noticed, one of the moms there decided to inform me that Cade had been sharing prayer "requests." As you can just imagine, I was the topic of conversation when he asked for prayer that as I underwent more surgeries, the doctors would start replacing some parts instead of taking them off.

I wasn't sure if they were expecting me to show up one-armed and able to decorate cupcakes with my toes or what, but from the looks on their faces when I told them who I was, I would say that I was not far off.

Kids and adults have obvious differences, but sometimes we could stand to learn a lot from them about how they cope with things. Laughter being a top priority, they are uninhibited and learn to overcome and deal with a myriad of difficulties, fears, and life itself.

Cancer is certainly not a funny subject, and I am not suggesting that we bury ourselves in denial and cackle at everything; rather, I am proposing that perhaps we need to give ourselves permission to laugh.

I specifically remember a time when I was shopping for groceries and stocking up on necessities several days before my first surgery. It was scheduled for two days before Christmas. While I was at Walmart, in the paper products aisle, all of a sudden I had this urge to scream at the top of my lungs and yell that this is not fair! Didn't they know that my Christmas was going to be awful and painful? I wasn't getting stuff for a party, I was having my own party knee-deep in pity because I was mad. Mad

because I had to have this surgery in the first place. Upset because I was having difficulty grasping just how my life was about to change. I hated it. As soon as the feelings came, they left. I like to call it situational Touretts Syndrome.

The most curious thing happened. I started to laugh. I thought, "Oh, I hope I wasn't transparent, and someone saw me! I'm a good Christian woman and I have to keep it together" . . . at least that is what I kept telling myself. My husband was in school to be a pastor, and it just wouldn't "do" to have his sweet little wife developing a bad case of situational terrets.

Where were these thoughts of performance coming from? Who cared if I laughed, but I did wonder . . . is it okay? Many people encouraged me to grieve, cry, and share my struggles, but I don't remember one single moment where someone told me it was okay to laugh. So I wondered: is this a normal reaction?

Laughing is a relief. For me, it keeps me real. It keeps things fresh and alive. There is precious little to laugh at after a cancer diagnosis, yet there is a fair share of that which is funny, ironic, or just plain hilarious!

Questions like "Are you pregnant or nursing?" become awkward . . .

The stares that people freely give you as you tell them you had breast cancer, well, they inevitably end up staring straight at your chest leaving you feeling vulnerable, and in a weird way, judged. Talk about a poor conversation starter! I laugh because knowing my awkward self I would probably do the same thing! Grace, people . . . we have to learn to give it even when someone else is living

through your own worst fear. It is best not to judge what you would do or not do until you are walking through it.

Speaking of fears, what is funny about fear?

Fear that once was a figment of your imagination is palpable and real. That certainly isn't funny. Yet, life quickly becomes precious, and with that realization, you see things through a different lens.

Cancer has taught me how to laugh. At myself, with people and not at them, and overall to sit back and enjoy the life that we have been given. Death as we talked about is all too real and certain for us all. But living through these trying times, I believe we can get a glimpse of glory when we laugh. When we surrender our hearts to the work that the Lord is doing in us during this time.

You begin to see that you are not looking at things through sick humor or through fear anymore. You don't laugh at your situation because it is funny . . . you laugh because you are free. Free in Jesus. You know that He is going to finish what He started, and He is more than able to deal with the backlash of what you face. Through the seasons of grief, you are able to laugh when facing a giant that used to hold you in fear. You are living your days as you were meant to live them: trusting in Jesus and being anxious for nothing. Oh, the irony! It sets a smile on my face as I think about it.

Instead of worrying about what lies ahead or what we haven't accomplished yet, we learn to be content in today. The here and now. It reminds me of something I learned about in scripture.

The Proverbs 31 woman didn't know what was ahead

of her either, but she did her best to prepare herself and her family for each day and didn't waste time over things that didn't matter or that were trivial . . . she lived knowing who she was in the security of whose child she was. She laughed at the days to come, and so should we.

"She is clothed with strength and dignity; she can laugh at the days to come. She speaks with wisdom, and faithful instruction is on her tongue" (Proverbs 31:25–26).

There isn't one person in this world who can control time or circumstance. Doesn't that give you a sense of freedom? Doesn't the fact that cancer or trials aren't in your control release something inside of you?

Could it be that we often lose ourselves and our mission here on earth when we receive a diagnosis of breast cancer? Any cancer? Or we are set back by tragedy? Perhaps we are faced with insurmountable odds and a series of disappointments and difficulties? Financial loss?

Girls, I am speaking directly to you now . . . challenging you along with myself to do something.

It is bold.

It is risky.

On this road to following Jesus, what does this diagnosis look like in my walk with Jesus? Does He know this Jesus girl struggles with fear? That she is struggling with being diagnosed with breast cancer? Does He really "get it" that I cannot do this alone?

You better believe it.

Regardless of our circumstances, think about this . . .

What if this is exactly what we were made for? What if this is our "for such a time as this" moment as we read about in the book of Esther? What if this series of events

is exactly the situation the Lord is allowing and using in our lives to give Him glory and to show Himself big through our lives and this situation? The very thing He is going to use in our life to overcome our greatest fears? To overcome the enemy?

He is very aware of what we are going through. Rest assured, He already knows how all of this is going to end.

Will you learn, along with me, to do all that we can to be like Jesus, and whether you are or have been bald like me, or have all your hair, will you learn to laugh? Laugh like the Proverbs 31 woman? Laugh at the days to come because you know what? When we learn to laugh, we begin to live. We live in the freedom that Christ died to give us.

We don't know what tomorrow holds, but we know who holds it. We laugh not because it is funny, but because the enemy cannot hold us captive anymore to our fears. When we learn to laugh, we are relying on the strength of the Lord to lead us, guide us, and to keep us . . . come what may. We are actually learning and living like a Christlike woman and taking the Lord at His word and trusting Him. Loving Him.

Yes, we become a dangerous threat to the enemy when we learn to live beyond our fears. I can almost imagine the enemy trembles when he realizes we are learning that Jesus will sustain us even through the bad times. Don't let him win the victory. The real victory is already won! Don't give him the pleasure of seeing us act out of control, bound by fears, or defeated.

If you have cancer, I want to encourage you . . . don't lose yourself in this battle. Find your strength and identity

in Jesus. Stand firm on His promises. Fly strong in His plans for you. He isn't concerned about the amount of hair we have or the weight we have gained. He is concerned about our hearts: where our focus is.

"Charm is deceptive and beauty is fleeting; but a woman who fears the Lord is to be praised. Give her the reward she has earned, and let her works bring her praise at the city gate" (Proverbs 31:30–31). I have a hunch that He receives glory . . . when bald people learn to laugh.

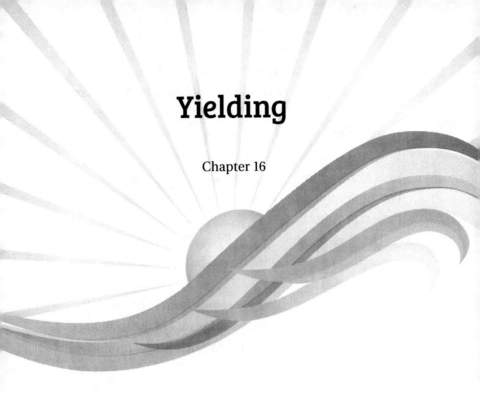

Yielding

Chapter 16

"Self-pity is our worst enemy and if we yield to it, we can never do anything wise in this world." —*Helen Keller*

As I sit with my peppermint creamer-laced coffee in hand, I am rocking on my front porch, covered with a soft, warm blanket handmade by a friend. Looking out over the field, morning is just beginning to yawn awake after hours of restful slumber, but not really. It has always shown, just not on this side of the earth.

The colors move from pinks, reds, and oranges to a simple shade of blue without ever clashing. Not once. Do you ever wonder how that happens? Who would have thought to take all those colors and then softly blend them into one?

And blue? I think that is the Lord's favorite color. The

ocean. Dominant eye color. Sky. A simple, four-letter word with so many definitions attached to it. Depression. The remote distance. The changing skin colors which are representing so many emotions or actions: anger, fear, indecent remarks, and their reactions.

It always makes me smile deep inside when I hear people compare the Lord to boring. Unattached. Or not even real. Amazing!

The birds are singing. Not flying. Odd. How did I never notice that before? Their first waking act is to praise. Sing. Make a joyful noise.

In the distance I hear the steady hum of highway traffic. Busyness and the obnoxious sound of the train horn just mere miles from my home. Such pitiful reminders of morning breaking on the horizon. Work. Another day. Constant repetition competing for my time, and at the moment, my attention. I almost get up and begin my morning routine.

But I stop. Begin pushing my chair back and forth, back and forth. I take another sip, a longer one this time, and savor the flavor. I listen, this time ignoring the chaos, and I smile. "Lord, you are everywhere." Not just here or there, but everywhere, all at the same time. The colors, the quiet, the birdsong, the breeze. Everywhere. I pause once more and take a deep breath. In . . . and out . . . In . . . and out again. It feels good. Refreshingly right.

Being in the season of menopause, I am beginning to love the new and funny changes. Take for instance when my mom calls me to get the 411 on some crazy symptoms. Or when you have to explain away a hot flash; realizing that the days of "glistening" (describing sweating

patterns) have now turned into listening to your body and attempting to ward off the coming tidal wave of moisture by shedding as many clothes as decent without giving away the stork's secret. Have mercy!

I have learned to take it in strides. Your clothes dry off. You will one day be able to pass your grandmalike fans off to another. And remember this, when they begin theirs, you will be done with yours. Yes, I will one day be able to listen as they explain away their own tidal wave of emotion and infernal heat. Until then . . . it is back to striding. Rocking. Nice and easy. Back and forth. This too shall pass.

What is still considered the change of life is changing lives—mine in particular. I have learned, along with the meaning of the word meno, that the key is less. Living with less. Less stuff. Less worry. Less stress. And definitely less hormones. The phrase that less is more? Very true.

Pausing is good. Like yielding at a stopsign. It means the temporary stopping or cessation of something. Pausing from the mundane to embrace the miraculous. Pausing from the worries, fears, and strife to digest the goodness of the Lord in the land of the living. Pausing from the more to living life with less.

Do you ever wonder why God chose women to carry such a beautiful picture? I do too, and if I were honest on days like today I would like to slap Eve. Hard. After the hormonal emotions subside, I realize that I too would probably have done the same thing. Isn't that what I find myself doing now?

I want more. More peace. More quiet. More of this.

More of that. More good news. More healing. More money. More time. Eventually I would have made my way around full circle and reached out for that juice-laden, fiber-filled piece of disobedience. I am certain that someway or somehow I would have made it come into my possession. Thus is the nature of the flesh. Well, mine anyway.

My mind circles in various directions as I consider all of the lessons we can learn from the first few chapters of Genesis. I guess that is one reason that the written Word was such a vital part of God's design for us to remember. So we could learn. Avoid the same disastrous path that some had taken. Chosen. Fallen on.

Perhaps that is why I write. Mainly for myself. To re-member. There really is only so much that you can ask of someone who has had chemo to remember or recall. "Chemo-brain" affects the best of us, and makes memo-ries last, at least for a moment. Don't worry, the brain recalls them, and eventually things normalize. I hope.

I love the Lord's sense of humor, don't you? At the end of these months and months of surgery, treatment, and recovery, I find myself in menopause. Only I am not stop-ping . . . just pausing. Yielding. I have to learn to worry less. And yet, pause more. Remember. Consider. Learn. Remember. Consider. Learn.

Much encouragement can be found in the scriptures. The written Word has so much power; it can move us and convict us in a pattern similar to a hot flash. Bear with me here . . . I do not intend to degrade the Holy Word by comparing it to something hormonal. On the contrary, think about this: when faced with the righteous,

loving Word of God, we are faced with a reaction. Do we let it simmer? Do we throw it off? It often falls on us like a too-warm blanket begging for some attention. If we are in the right conditions, we receive it openly. On a ninety-degree day? Not so much.

Much like the irrational patterns we face at midlife, it is difficult to understand the sin nature in us. As Paul writes, we do the things we don't want to do. I don't want to be too hard on my now black-eyed picture of Eve, but I do believe we each have a choice, similar to hers: one involving obedience.

Obedience is a call to less while pausing and waiting for His increase. It brings us to the point of boiling at times, only to have the euphoric joy of a long-awaited promise fulfilled. Sometimes, if we are honest, the only thing that keeps us on the obedient straight and narrow is the promise of something to come. I believe that that is one of the reasons the Lord placed such language in His Word. He knows the human nature. He created it. Thus, it gives you the chills too.

Oh, how I wish at times that my heart would always desire the best of things!

You know I mentioned exercise? Did you know that doing thirty minutes per day has amazing effects? Not just on your waistline, but emotionally. Mentally. Physically. Research shows that thirty to sixty minutes of exercise can reduce your risk of reoccurance by fifty percent? They don't make drugs that can do that.

Plod on with me friends . . .

While working with my trainer one day, she kept telling me, "Don't stop." I was struggling with an endurance

exercise. A few moments later she was saying, "Slow and steady . . . that's it . . . now stop."

There is a time for everything. In this season I am learning about "less" and "pausing." Menopause too. No, I am not a saint, just a forgiven sinner who now has the urge to slap people once in a while, but must learn to observe and then put into motion what I have learned from even the birds. Praise. The simple first act of the morning. Before everything else.

"He has showed you, O man, what is good. And what does the Lord require of you? To act justly and to love mercy and to walk humbly with your God" (Micah 6:8).

It is our choice whether we will obey or not. It is up to us if we want to reduce our risk and go for a walk. For now, I am content to rock back and forth to the rhythym of the slow, now pause, slow, now pause pace that I am now in. Yes, with a fan and a few less layers, this Jesus girl is learning about what is good and what it means to walk humbly with her God.

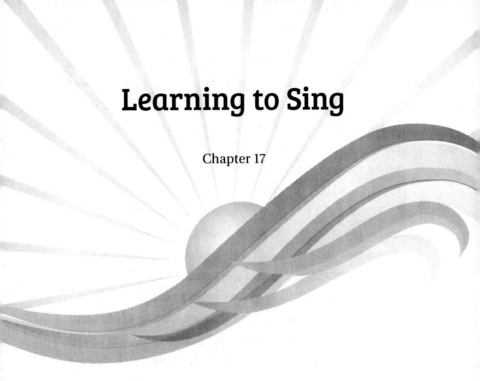

Learning to Sing

Chapter 17

"Sing praises to God, sing praises; sing praises to our King,
sing praises!" (Psalm 47:6 NLT)

I love to sing.

Praise is something altogether different, something that over time, out of my love and obedience to Jesus, I have come to love doing. Songs have long been a method of expressing love through lyrical genius. Poetry and musical notes in a well-blended balance of melody and harmony. Perfect timing.

Music has a way of reaching past the places where encouragement settles and into the crevices of a broken heart, a healed heart looking for comfort, or a heart simply needing relaxation.

When I was learning to play piano, I would watch

the minutes on the timer tick by. Second after second. Minute after minute. Longing for the thirty minutes of mandatory artistic torture to be over. As I look back years later, I think about how much I would LOVE to have thirty minutes in which to practice songs that have come to be an expression of praise, prayer, and love to Jesus. It makes me truly happy.

There isn't a memory of mine that doesn't include music on my mom's side of the family. We have often joked that if you can't sing, just sing louder! That will force the good singers forward, and the result is perfect harmony. It seems as if the music gets sweeter as time marches on. Perhaps it is the weathering that we receive when walking through life that changes our perspective, but I have seen that families have a bond that goes much deeper than blood, like what is seen in our faith family.

No one ever desires to go through cancer, much less the long, difficult treatment that follows. But that is exactly the road the Lord has taken me on. I have been comforted time and time again by music. Some new, some old, but all of it filled with praise.

I remember the day my doctor called and told me that it was cancer. After I pulled myself off the floor, I remember walking over to the CD player and listening to one of my favorite songs. As "A Mighty Fortress" played that afternoon, I really began to hear the words as Christy Nockels belted the chorus for the final time. Sure I knew what it meant, but I was hearing it with new eyes and a knowing heart. I needed that fortress. I needed the comfort that came through musical excellence.

It truly has been a humbling journey. Not only has the

outpouring of love and support brought us comfort, but the pain, grief, and fear have brought us to our knees. It has shaken the very core of what we believe, and shown us a side of God that I had begun asking Him to show me: His GOODNESS. Yes, His unshakable goodness shown to us through cancer, in surgery, my weakness, pain, disappointment, and even in my grief. He has been the refuge I sought, the fortress I ran to. HE IS GOOD.

I see the battle scars that many wear all around us . . . the list could go on and on were we to begin writing it down. Yet I have seen and heard a beautiful harmony out of our faith family and out of our own hearts as those who are going through or have overcome these things sing louder. The shared faith and hope we have in Jesus alone, is a song / battle cry for all of us to join in singing, to show the world the hope of Jesus. He has OVERCOME this world.

The road we have all been given to walk is not easy. But there is a freedom in surrendering to Jesus and a peace in letting go. Really trusting in Him. Will you take just a minute with me and sing? I'm just learning yet. Let's sing out, my friend. Sing loud! Through our pain/ trials we have an opportunity for our faith to become sight. To say like Job, 'My ears had heard of you, but now my eyes have seen you'" (Job 42:5). When we keep our eyes on Jesus and allow Him to finish His work, we can hear the beautiful, blended harmony. To "taste and see that the Lord is good" (Ps. 34:8).

Our faith in Jesus, is the victory that overcomes the world.

Take Two...

Chapter 18

"You are my hiding place and my shield; I hope in your word" (Psalm 119:114 NCV).

I mentioned that I used to look at the timer and dread the thirty minutes of practice that was required by my parents. Their investment was needing a guarantee, and I was not doing my part. One day, my mom decided that if I dragged out my practice time, I could do it over. Not good. I sort of had to have a "take two" moment at that point in life and learn things the hard way or the easy. The choice was mine.

Once again, I am working against distractions. Another take two moment. Do you ever have those? You wish you could "do over," but you are left with a "try again."

I was able to attend Cade's Christmas party at school. It is so much fun to work on their little crafts, hand out the snacks, and sort of get to stand on the sidelines and watch the kids interact. I just want to give a little shout out to all teachers: you all are saints and I could NEVER do your job. Your patience and your persistance with the kids is amazing, and the fact that you come back year after year . . . well, you earn an award in my book! I was ready for a break, nap, or something about the sixth time I got the little sticky jewel things (for the foam Christmas tree craft) stuck in my (fake) nails; then there were the attitudes of the children that made me want to write a tattletale letter to Santa.

Later that same evening as I was cutting Aaron's hair, he was asking about my day. I told him it was just one of those moments in life that you could just take two. You know? Just a small break. As for my day? It entailed a great deal and only included Target, Walmart, and Famous Footwear. Most people would think I make this stuff up—oh, if I could wish it! I can't even process it most of the time, let alone think it up! Besides . . . Cade was a witness to it this time, and even he just shook his head and laughed. Aaron? He just laughed hysterically imagining all this . . .

While at Walmart I was patiently waiting for an elderly gentleman to walk out the doors. Apparently he thought I was following a little close behind him because he turned around and hocked a wad of "disgustingness" right at my feet. I stood still in disbelief, causing a backup in the exit line, all the while deciding how to navigate around "it." Let me just say . . . super gross.

Driving from Cade's school to Liberty, I passed a mini-van who was in the other lane. About a mile down the road, as he passed me, he honked his horn and (I am NOT kidding) stuck his tongue out at me, waved at me, and then cut me off. Seriously? Is he five years old? By this time I had already had it. Remember the Christmas party, nails, and the naughty letter to Santa? Yes, that already happened. My cup was full, and my day was only half done.

I was wondering how I was finding myself in this situation. Things had started off so well. So, as I stood in line at Famous Footwear, I was just getting to the register with my purchases when this older woman walked up and swatted my rear and gave me a pinch, then apparently had a "coming to her senses" moment and realized that I wasn't "sweetie," but some innocent woman she just violated. Not sure about that one . . . I don't remember my *own* mom doing that except with the yardstick, standing in line with my siblings because we all usually had it coming, but in a store and being VERY familiar, things were a little awkward. It was time for me to take my "behind back to the beehive". So home we went.

As Aaron laughed, I just shook my head. Why do these things happen? To me? I in NO way invited them, but here I sit contemplating how in the world I got to where I was that day. I was getting distracted. Distrusting of people too. You know the familiar road our minds travel down if we let them?

I am in the middle of a Bible Study called *Jonah: Navigating a Life Interrupted*. Appropriate, I thought. Life is full of them: unexpected blessings; failures; miscarrages;

infertility; new baby or two; job loss or change; success; sickness; cancer; death; loss of abilities due to some of the other things; fickle friendships, or unforgiving friends; disappointment after disappointment or blessing after blessing; and even swats on the behind. Either way they are all interruptions and distractions. Depending on how we handle them . . . well, that determines our own outcome.

Priscilla Shirer, the author of the study, said, "If you find yourself balking at God's instructions in your life, it is an indication of the importance you place on God and His will." Ouch.

His instructions for us are laid out in His Word. He teaches us through song, prayer, reading His Word, and through people. Yes, even people like the guy who stuck his tongue out at me. It wasn't a "the world is against me" kind of day. It was a day of testing. Things happening that were silly. Rude. And just plain dumb. I often find that these are the things He uses.

I don't believe that God intended any of us to go through pain and suffering, but that became a natural consequence when mankind determined to have free choice back in the garden of Eden. I believe that the Lord has sovereign control over EVERYTHING and we STILL have the freedom to choose Him and His way regardless of any circumstance.

I take great confidence in the fact that whatever happens to us, good or bad, can be just that—good or bad. Although Satan means it for bad, God can make good out of every situation when we let Him. Here's the catch—we want health and wealth, but Jesus is focused on a more

eternal perspective. Not the temporal. I like to say that my eternal "health" has earthly benefits and drawbacks, but I would NEVER go back. The drawbacks are simply selfish on my part, because it is only natural to not want pain and suffering and to take the easy way out.

I recall reading about Jesus. He was just about to be arrested. As He prayed, He asked to be removed from the situation. " 'My Father, if it is not possible for this cup to be taken away unless I drink it, may your will be done' " (Matthew 26:42). Jesus Himself was asking to be taken away from the awful task that lay in front of Him.

Because sin came into the world through a decision, God made a way to bridge the gap that stood between us and Him. He made provision. It was Jesus. Up until this point in the Old Testament, sacrifices were made for the atonement of sin. Enough was enough. Jesus came as God's own Son, fully human and yet fully God. Born of a virgin, He came to suffer once and for all for you and for me. To have fellowship. Oneness. A much-needed Savior.

If we were honest, how many of us would die in place of another person, let alone carry the iniquity of all mankind on our shoulders? Would there be a show of hands that would voluntarily say they would be like Jesus and have a take two moment, where you would say take them both—my will and Yours? Let YOUR will be done. That takes a love and a power that are not of this world. I NEED a Savior. I NEED Jesus. And recognizing that need not only keeps me humble, but thankful and dependent. Would I be willing to give my life up for stick-your-tongue-out guy? What about super-swatter shopper lady? Would I be willing to go through with whatever

the Lord was asking of me for His will?

Navigating through this world of distractions and interruptions puts me in the same place—distracted and interrupted. Distracted from the things not of this world, but by the things of this world. Interrupted in the same way. The above question shines a spotlight on my heart's motives and my wants/desires. How we react in each and every situation whether it be the store, getting pinched, or through things like cancer is often very telling.

I would love to lie and say that I just handle everything with grace, but fortunately, with Jesus living in me, I have the opportunity to be honest. Scripture tells us that the truth sets us free (John 8:32). It is speaking of Jesus, but I believe it is true in life too. Don't be discouraged when you/we find ourselves falling short next to the Word of God. Let it be a reminder that God is not only a God who saves (note: that would have been and IS more than enough), but He is One who heals and restores and is the author of do-overs. He gives us chance after chance for the take two moments.

I cannot say I would die for Mr. Wanna-hock-a-lugue, but I am closer. I don't want to be frustrated by my slow growth or distracted by things that don't matter. I am choosing today that I won't. I won't quit. I won't give up. Let us learn together through this life He's given us to be just like Him. His will, His way. "If it is not possible for this cup to be taken away . . ." take two, and "may your will be done." Thank you, Jesus.

The Voice in the Whirlwind

Chapter 19

As I sit here typing on my laptop, it is ninety degrees outside. I have just finished a week at Kid's Camp and a large cup of coffee. I should have thought about the coffee BEFORE Kid's Camp, but regardless—here I sit. Wrapped in a blanket, pillow propping up the computer, and my little boy working feverishly on an art project.

I love days like today. Days where the dishes are washed and put away. Days where the laundry is caught up, and I am able to sit with my feet propped up, and I can write. Days where the lawn is mowed, and the flowers are watered and thoroughly nourished. After a take two kind of day, I needed this.

Everything seems perfect—yet isn't.

I celebrated my one year in remission with 155 kiddos at church camp. I served with four great friends in

the kitchen, serving meals twenty four / seven, or so it seemed. I rejoiced in that moment when my physician told me the great news. I wanted to go out and celebrate, yet another meal was calling. My doctor appointment break was over, and back to real life I went.

Life is like that. Sort of like a thunderstorm where the hot air collides with the cool air and makes the thunder echo across the land and the wind sweep by in various patterns, going exactly where the Lord is calling it out from.

Recently I read the story in Mark where Jesus calms the storm (Mark 4:35–41). The storm blew up, but was not just any storm, but one "furious squall." The Greek Dictionary defines it as a "storm, hurricane, whirlwind . . . wind, gale." Something so fierce that the waves were lapping over the sides of the boat.

Don't you love the understated fear that surely was present? Also, I wonder what happened to the "other boats" that were with them? Well, what information we are given shows Jesus asleep on a cushion.

Unconcerned.

Dozing.

Completely comfortable and trusting the rudder while asleep at the stern.

When He got up, He rebuked the wind and said to the waves, "Quiet! Be still!" The wind and waves obeyed Him.

Completely calm.

He was in complete control.

And He still is.

This week was one of fun, tiredness, and improvising at times, but below the surface there was work being

done on the hearts and souls of over one hundred kids.

This week was one of great news.

This week was also a difficult one. One where faith was again being tested, just like in the boat.

A sweet friend of ours found that cancer had silently been gathering in her body like an ominous storm cloud, darkening the skies of good health. The news, it seemed, came one after the other like a hurricane-forced wave, threatening to bend the strongest of trees, like faith that had been carefully planted.

Why?

Why does it seems like time and time again these things pop up? It used to happen to people we didn't know and sadly enough, that was okay. It didn't flood the normalcy of my life. It didn't soak my carefully put together dreams.

Bad news has a way of forcing itself into our lives with the force of a strong gale. It leaves our emotions bent and broken similar to the aftermath of a whirlwind. Nothing in this world prepares us for bad news. No amount of worry or fear will make it go away or change.

Nahum 1:3,4,7 says that "The Lord is slow to anger and great in power . . . His way is in the whirlwind and the storm . . . He rebukes the sea . . . The Lord is good, a refuge in times of trouble. He cares for those who trust in him."

Never will we ever be able to discern the way of the Lord. We can trust that He is in control, but will probably never be able to know all of the "whys" that happen to us or the hurricanes of trouble that molest even the quietest of lives in this world. Why her? Why me?

If you are like me, just trusting seems such an inadequate tool to use against so much damage that can come with a cancer diagnosis. It is. By itself it is nothing.

My grandma McDonald once said that "every event is an opportunity for greatness." Words of the wise.

Greatness in a Christian's life can only be defined by looking through the eyes of the cross. There was suffering, and even death. Will that be how everything ends? Yes, but not in the way we always think it will. The cross does clue us in to why suffering, sadness, pain, and even death hurt us so much in their aftermath.

If we look through the eyes of the Word, we will see the original plan included personal, intimate fellowship with Him for all of eternity. It wasn't intended that we suffer.

Eden.

I can almost smell the sweet aroma on the gentle breeze.

Perhaps my peppermint or French vanilla creamer would have been among the sweetness wafting around my perfect, cancerless form. No scars. No pain. No worry to threaten my shores. No fear to form even more wrinkles around these knowing eyes.

I wish there was a way to rebuke all of that. Yes, even the wrinkles. Those expensive creams are simply overrated—just sayin'. I wish all these good things and more for my family. For my dear, sweet friend.

The reason we struggle with bad news like we do is because we physically see and feel the spiritual struggle taking place around us. Yes, with hurricane-force winds, we see the supernatural collide with the mortal/

sinful nature that we currently live in with the obnoxious sound of thunder threatening the "game" of our life.

Eternity was set in our hearts at the beginning of creation.

The fight to live is what remains of that. An echo of Eden.

We struggle to grasp on to something solid, foundational, when all else seems to be crumbling. We grab on to life when life ebbs from our grasp. When cancer corners us and threatens like an ominous storm. When financial stress pins us down in a checkmate.

With the decision to sin came the curse because of sin, thus the reason we struggle with death and disappointment in this life. Oh, how I wish things could go differently, but in the same breath, I rejoice that they don't. We have heaven awaiting us. If it is indeed precious when one of His saints pass away, then we are in for a huge homecoming. A celebration for sure. Music. Dancing. Praise. Wholeness.

We won't have to worry about looking over our shoulder. Or waiting for the other shoe to drop. It will be a long-forgotten memory, packed away with the hurts of the life we now know. But what about today?

We can react in fear to these things, or we can hold on to faith.

We can question: is the Lord asleep in the stern, or is He in the whirlwind?

One thing I know for sure, He is in both. He is in complete control and calling to us.

Calling us deeper.

Calling us closer.

You can trust Him who is trustworthy.

Though the waves threaten to swamp your boat . . . hold on. He who calls forth the wind is calling us out of our comfort zones and into the calm, despite the storm.

Hold on.

Be Still.

And Listen.

His voice is in the whirlwind.

Where is God When Life is Hard?

Chapter 20

"Trouble and distress have come upon me, but your commands give me delight" (Psalm 119:143).

Butterflies are beautiful to me. They always have been, and after this, they always will be. They serve as a direct reminder that the Lord, the Most High, is everywhere and is working in all things.

As I have figured out, you can never stop learning. There is always something you don't know. I would venture a guess that many of you never knew that a butterfly's skeletal system is on the outside of its body. The purpose of this is to maintain the water content inside the butterfly, preventing it from drying out.

A butterfly undergoes four stages before it truly becomes a butterfly. The stages start as an egg, moving to

a caterpillar, then to the chrysalis stage, and eventually the adult butterfly. Each stage is unique and essential for the end goal or result.

Much like the stages of the butterfly, our lives—each step, are carefully laid out by a greater plan, one that is defined by order and precision. The butterfly must lay her eggs onto the leaves that her eggs can feast on when they hatch. The Lord, in the same way, places us exactly where we will grow the most. His strategy is based on our need, not His. It is a result of His plan, not ours.

Once a caterpillar begins eating, it immediately begins to stretch and grow. Everything it needs to carry out each stage is provided for it right where it is. Exactly where it is. All it has to do is open its mouth and eat.

Through the very Word of God, we have the same thing. The Bible is as edible as the "leaf" that we are currently on. 2 Peter 1:3 says, "His divine power has given us everything we need for life and godliness through our knowledge of him who called us by his own glory and goodness." Romans 8:28 adds, "And we know that in all things God works for the good of those who love him, who have been called according to his purpose."

I love these verses. They give me hope. Encourage me to trust. Grow my faith in a Creator who is bigger than me, but handles me with the utmost care, lovingly placing me where I will grow. I can almost picture the face of the Lord the same way it was with me in the ultrasound room: with smiling eyes and hand over His mouth to hold back His smile and laughter as He takes a front row seat in watching His beauty unfold in us. You and me. He is there to cheer us on. To keep us on

the leaf of life. He has given us everything we need.

The beauty of the parallel we see here between our lives and the butterfly is the constant glory that it brings to the Lord as things are carried out exactly as He intended. He is there, and He is in the details. He cares about us so individually and with such careful attention to detail. I know life is difficult. Times are hard. It seems more often than not, our vision is blurred. Our colorful perspective becomes limited, but like the butterfly (who can only see three colors), we must learn to use all of our senses to see the goodness of the Lord during difficult times.

As people, we process difficult or hard times differently. There is such a vast variety of personalities and how we process trials in our lives. Common ways you see people deal with these trials are to shut down, be in denial, act out of anger, or cope. I think I have done one or all of these at one time or another. We all probably have. NO ONE LIKES HARD TIMES.

I have found that it is during these hard times that we are faced with things we would have never put in front of ourselves before. We are brought to our knees and humbled in ways we would have never chosen for ourselves. It is devastating, difficult to grasp, and overwhelming. And like the butterfly, it requires change, a metamorphosislike transition from what we were into who He wants us to be.

Until a couple of years ago I was living what I would consider a "good" Christian life. It included all the right things. I went to church, gave my tithe, served where I was serving with a right attitude. But I was missing

something. Perhaps missing is too strong a word. I was lacking in one thing. Underschooled in how to love myself and others.

Love. Pure, and unadulterated love.

Jesus asks us to have love in everything. It wasn't that I didn't love people, because I truly do, but I often made my attitude my religion—just as I liked it— somewhere between where I was comfortable and where it wouldn't cause me and my family to have too hectic a schedule if we included God now and then. I didn't consult with the Lord about my schedule. I figured that was my job. I loved having a day planner to work off of. Each of us knew where everyone was and where we were going. It worked and I liked it. It isn't wrong to have a schedule, but I didn't stop once to think that perhaps some or all of the things that I had on my day planner were things that I was "doing" under the guise of "because I want to" instead of "Lord, is this what you want for me to do today, or my family to do?"

When I would see someone going through difficult times, I truly felt sorry for them. I would cry with them, hug them, take a meal, encourage them. Whatever immediate need they had, I would try to fill it or fix it. Until recently, I didn't realize my attitude toward them was misguided. I would love them, but I didn't want to get my hands dirty with the baggage that came with them. It was much easier to walk away than to listen over and over to their difficulties, or how they were working through something. It was especially difficult if that "something" they were working through was the very thing I feared for myself or my family. I guess you could

say I wanted to fix them, and if I couldn't, I would in a mental sort of way "wash my hands" of them.

Loving someone takes time. As for loving yourself . . . a lifetime. A lot of time, patience, forgiveness, work—everything that is listed in 1 Corinthians 13:1–8a (The Message):

"Love never gives up.
Love cares more for others than for self.
Love doesn't want what it doesn't have.
Love doesn't strut,
Doesn't have a swelled head,
Doesn't force itself on others,
Isn't always "me first,"
Doesn't fly off the handle,
Doesn't keep score of the sins of others,
Doesn't revel when others grovel,
Takes pleasure in the flowering of truth,
Puts up with anything,
Trusts God always,
Always looks for the best,
Never looks back,
But keeps going to the end.
Love never dies,"

The Holy Spirit alone has the power to change someone.

I began asking the Lord several years ago what He was working on in my life. I couldn't see (as we often can't) where He was working, but I knew He was up to something big. Something that would challenge everything I believed in. My world was about to change. I guess you

could say that I was moving into the third stage of the butterfly—the chrysalis. The most uncomfortable, awkward, and completely transforming stage was about to begin for me. Enter cancer.

The first time that I "saw" the Lord's hand in this journey was right before I found it. You see, I used to live in fear of something exactly like this happening. What if? was a question that plagued my heart.

My fears grew with me as I moved from a child into a woman. I remember one time as a child thinking that I could make people love me if I was only good enough. So I tried. I manipulated. I was desperately seeking to fill a void. It would take me many years and much pain to see that I was enough. I am enough.

I can honestly say I was disappointed when He just didn't make the cancer go away before surgery, but I believe that even though He didn't answer that prayer, He has answered something bigger—His plan.

The Lord has completely rearranged my "schedule" and is teaching me a deeper meaning of "love." Beginning with how to love myself. You cannot give someone something you don't have. I have said that many times. I never realized that I was loving people only with the capacity that I loved myself. I would doubt people, withhold, be skeptical, frustrated, etc. I would genuinely feel disrupted inside, but never loved them completely, as God loved us. 'For God so loved the world that he gave his one and only Son, that whoever believes in him shall not perish but have eternal life' (John 3:16). He loved us so completely that He gave everything He had, even his precious Son, for me. He never hesitated, withheld,

or was frustrated. He never doubted that I was good enough for Him. He loved me for me, and then some. He does this for each of us.

What I am coming to realize in this third stage of my life is that He placed me right in the middle of not only my mess, but that of those around me dealing with things that no one wants to go through or deal with. Who wants to talk about cancer? Better yet, what in the world do you say to someone who isn't going to live much longer?

At times the Lord has given me words, but I have seen that more importantly, we just have to be the hands and feet of Christ, as uncomfortable as it is. It is dirty, messy, and it is tough. There have been times when I have watched people get sick—literally. Some don't come back to treatment because they are dying. You make friends there, and you lose friends there. I have learned a lot while sitting there week after week, day after day, having no control of my own situation.

At times I was unable to care for my son or my husband because of sickness or treatment days when I was gone. Friends, family, and my husband have stepped up and helped in so many ways. Even still today. It is truly, truly humbling. I was being forced to trust, but I have also learned just how much this pleases the Father when I put my trust in Him and not my circumstances.

Humility has a way of taking our focus off of these things. Much of my schedule was filled with appointments. Today, my schedule isn't quite so full, but just enough to keep me remembering where I have come from. The irony of all of this is I am happier than I thought possible going through this and coming out on the other

side. I cannot explain it to you. I was a simple, broken, scarred, and bald woman who has had a new revelation of who God is, and what amazing love really is when we trust in God.

In Whom Do You Believe?

Chapter 21

"I know not why God's wondrous grace to me He hath made known, nor why, unworthy, Christ in love redeemed me for His own. But I know whom I have believed, and am persuaded that he is able to keep that which I've committed unto Him against that day."
—Daniel W. Whittle and James McGranahan

Many people ask interesting questions or have very pointed comments when hardship comes on a person. "Was this a result of their sin?" or "Perhaps they deserved that." All these questions are not new. The Bible includes some of these very same questions, directed at Jesus.

In John 9 there was a man who was blind from birth. The disciples asked him, "Rabbi, who sinned, this man

or his parents, that he was born blind?" (verse 2) Jesus said that neither this man nor his parents had sinned, "but this happened so that the work of God might be displayed in his life" (verse 3). Jesus then spit on the ground, made some mud with the saliva, put it on the man's eyes, and told him to go and wash. When he came back home, he could see.

The religious leaders of the day began to question the man who was born blind. At first the man declared that Jesus was a "prophet" when asked who he thought Jesus was. They questioned his parents, and then the man once more. This time he answered, 'Whether (this man) is a sinner or not, I don't know. One thing I do know. I was blind but now I see!' " (verse 26)

His own transformation was happening in this severe questioning from the Pharisees. He is about to be thrown out of their religious system for his association with Christ. He told them that if Jesus was not of God, then He would not have been able to heal like He did. And with his answer, he was thrown out of the synagogue. The longer he experienced his "new life," the more confident he became in the Qne who had healed him. This man encountered Jesus once more, and when Jesus told him that yes, He is the Son of Man, the man worshipped him and said, "Lord, I believe."

I love the way this man seems to gain confidence throughout the story. It is sort of like when a butterfly emerges from the chrysalis stage: the wings are folded together, but as it rests, it very slowly begins to pump blood into its wings by opening and closing and repeating this process until they are fully expanded.

I am not an authority on this, but one thing I do know: God is good, even when life is not. I am seeing it with my own eyes. He is asking me to live what I believe. It takes work like the opening and closing of the wings, and basically boils down to this one question—DO I BELIEVE IN HIM OR NOT?

Sometimes the most desert-looking ground is actually the most fertile ground, with the potential to grow and produce more than anyone gave it credit for. Similar to the little leaf that looks just like any other. Who knew it could have the potential to help in producing a beautiful butterfly reflecting His glory? How in the world can breast cancer be something good? I don't know, but I see the good coming out of it because I am seeing the Lord through it.

My heart keeps asking so many questions, and I would like to say I have an answer for each one, but with my decision to trust the Lord I have had to let the questions go. I have to surrender. Give it all to Him. Is it easy? Not one bit. Remember my schedule? There are days where I am still trying to convince the Lord that I really liked that . . . and that it didn't have to change!

I prayed from the beginning that the Lord would protect me from offense from what people would say, and He has. Here are some of the crazy questions / priceless jewels that have brought me a lot of laughs.

I may never forget my wig flying off in Thoroughbred Ford's parking lot and freaking the salesman out! He was suddenly called away for some "urgent" reason.

Please don't do your own breast check in front of me either. It is rather awkward.

Finding the joy in this has helped me cope. Choosing joy in this has changed my life. Removing the bandages off my chest was almost more than I could bear. Yet seeing these scars reminds me of all that God is doing and going to do in my life. I can totally relate to the blind man in more ways than one. I, too, was blinded/shortsighted, but now I see.

So, where is God when life is hard? From the eyes of this simple girl, He is right here, and He will NEVER leave. Ironically, being bald taught me that I have nothing to hide. This is the me that I am learning to love. It is more than physical beauty. Believe me—it can be taken in a moment, but His love lasts forever. This same love is changing everything about how I love other people as well.

Jesus is love, and His love is in the hardships of life, because He will never leave us. Though our world is shaken, nothing can shake Him from His throne nor from our side. Romans 8:38–39 says, "For I am convinced that neither death nor life, neither angels nor demons, neither the present nor the future, nor any powers, neither height nor depth, nor anything else in all creation, will be able to separate us from the love of God that is in Christ Jesus our Lord." His death is proof of His unconquerable love. Nothing can stop or prevent His constant presence with us. God tells us how great His love is for us so that we can stand secure in Him. In our trials and in our life. He is glorified when we believe in Him. Regardless of our circumstances.

Do you know the final stage of the butterfly? As an adult, its one and only mission is to reproduce. Like the

butterfly, our stories need to be told as a way of reproducing God's goodness in a world where very few believe. We need to tell of the great love that God has for us, and by trusting in Him we can have forgiveness of our sins and eternal life with Him that lasts far beyond our hardships in this life. God is good, and we can trust that He has a perfect plan. It may be in stages like the butterfly, but we can be "confident of this, that he who began a good work in you will carry it on to completion until the day of Christ Jesus" (Philippians 1:6).

God is in each stage of our lives and is waiting to give each one of us a flourishing finish on the day Christ appears. It is time to spread our wings and reflect His glory.

So my question to you is this—In whom do you believe?

Through Waters Deep

Chapter 22

"My cup overflows" (Psalm 23:5b).

My Heart overflows this morning . . .

I look out over the freshly watered lawn and I breathe. A deep, full breath of the clean, rainwashed air. Fresh. New. Alive.

Everything looks greener. Happier. Is it my imagination or do the birds sing just that much sweeter a song-like melody?

Nothing starts a day off right like a birdsong, echoing my own heart as I wake up my family for a new day. Correction . . . I wake up Cade for the new day. My man has to get me up each morning to face the day. But if I am up, then I am running!

The day begins after a weekend of what some are

calling "rain." Whatever it is called, I am thankful.

Cade is growing so fast. Now in school he is loving every minute of it. Well, recess anyway. How can it seem like only yesterday when I felt his warm little body for the first time and introduced myself as his mama? Hard to imagine what those big blue-green eyes were thinking when they first laid eyes on the world. After breakfast this morning, Cade asked me to dance. So we did. Ballroom. Jazz. Rock and roll. Hip-Hop. Line dance. We did it all. As he hopped into my friend's car to drive off to school, that sweet. Cherubic face looked out through the window and waved good-bye. He is off to a world of learning in the first grade. Off to one more day of tasting and seeing that the Lord is good.

It starts with me. How incredibly heavy that feels at times, but also so good. I have learned that it isn't in the trying of things, it is in the doing. The trying often sidetracks me because it at times implies the temporary. I desire for what I teach Him in Jesus to be permanent. Lasting. Longer than just a minute.

I love that little boy. I cannot tell you just how honored I am to be his mama. My mind can hardly take it in. We have danced a road these recent years, but never alone. We have had each other and the Lord.

And speaking of each other, I realize that I don't brag enough about my man. He is one of a kind. The one in a million that I am blessed to do life with. He works hard, plays hard, and loves life. He supports me when my one ounce of estrogen flares. He loves Cade into submission. He has loved me into remission. He wants to start a support group for men whose wives love Pinterest. He often

fills his schedule up for others, but rarely have I heard even a complaint! He fills in for Sunday School teachers. Besides leading worship at church, he has been diligently working away at getting a degree in church ministry, one class at a time in seminary. Yes, his plate is full, but as I said earlier, he rarely complains.

I love that man.

Each and every day I am reminded. I am thankful for life. I love living. I recently saw a picture of me without hair, and it literally made me cry. Yes, the one ounce of estrogen lives. Viva la estrogen.

I embrace this new change of life. It is difficult. Painful at times. But I am learning to roll with it. Not looking back unless it is to move forward. Looking forward makes me discontent in today. So I am leaning to float. To relax in the pools of today. The blessings flood my soul as I look around me.

The greening grass.

The dew-soaked deck.

The singing birds.

The smell of the barnyard.

The taste of happiness in the dance with my little boy and in the warm embrace of my man as he goes off to work.

Yes, this heart overflows.

Psalm 23 has become so precious to me. I have begun to see the life, adventure, guidance, protection, warrior side of God as He draws me near with His staff and fends off the enemy with His rod. Oh, how I love my Jesus. He is restoring this soul, piece by broken piece, and mending it for His glory and purpose. At times I don't know

what to write . . . here in my book. Words will never be enough.

There is so much I wish to say, but no words come at times like this. It's like a personal journey that is written for the world to see. I often want to hide when I think about people reading my innermost thoughts. The vulnerable times. The broken times.

Many mountain Highs and steep valleys low.

"My cup overflows" (Psalm 23:5b).

He has sustained me through waters deep.

For today . . . that is enough.

Life through the School Window

Chapter 23

"He provides rain for the earth; he sends water on the countryside" (Job 5:10).

Here I am, back at the schoolwork window. Yes, I've written here before. Writing on this book while the teachers and students are hard at work, I find the irony of my situation. Why in the world would anyone care about what I write? I keep asking myself this question, but I also come to this realization. If each chapter could bring healing to just one person, and if that is all that it ever reached, would that be worth it? My answer is yes. So I write. And will keep writing. Here, in a blog, in a letter of encouragement. Life continues just like it does out this little two-by-four-foot window of my little world, here at my sons school.

As I have plugged away with writing as my dead-line quickly approaches, I am reminded over and over again of God's faithfulness. Just the other day I picked up my journal and reread some things that I had written. I wanted to share this with you:

This next Monday I go for my fifteen-month remis-sion checkup. Whoo hoo!!!! I have to see an new physician this time I go, due to the fact my oncolo-gist left the practice he was at. He left to go teach at a nearby college. He is down to seeing patients one day per week, at a new office about an hour away. I will take up with him again as soon as he is established there. However, there is a bit of fear and trembling as I am in another physician's care. Are they competent? Yes. So what is the big deal? I know . . . for goodness sakes I'm a big baby! I don't like change that much . . . rather, I "still" don't like change that much. I know that You know, Lord. Keep me focused on You. Let me see Your face in this.

My last surgery is scheduled for Sept. 20th. YEAH!!!! This will be the sixth and LORD WILLING the final of the year. What a year this has been. I feel the normal (panic) preparations beginning. I am so sick of this. I know what recovery will be like so I am cleaning, helping, doing what I can now, so that in times of rest, I can do just that. So thankful to be at this point!!! Yes, thankful and scared too. Will accepting the new "changes" be a good change? My thoughts

are rolling, Lord. Worries about. Forgive me, dear Jesus. I trust in You. Help my unbelief!

I noticed just how green the grass turned as soon as we had rain. This has been the longest recorded year without rain all summer. It was like looking at a picture changing colors. I thought about my faith as I watched it turn. I thought about the times that I just "give up" or want to give up hope. Then, when my prayers get answered it seemed as if I never doubted, never tired. Oh, how fickle I am! I can so relate with the people of the Bible. What some call dramatic is even more so in our day. In a time where we don't see the pillar of cloud by day and one of fire by night.

I long to be pure in heart as mentioned in Matthew 5. They are blessed and they will see God! What an amazing thought! It is one that I don't often think of as I clumsily make my way through the day just trying to get through. I think of being pure in heart as being single-mindedly focused on one thing: Jesus. Making my day revolve around Him instead of trying to fit Him in here and there into the places where I want Him.

My heart being prone to wander is often like the grass. Dry, withered, and in need of some root-deep nourishment. The grass is dependent on its master to provide for it. It cannot just make rain come. We are much the same, however, with the ability to fill

our hearts, minds, and souls with the Word. Read-
ing, worshiping, prayer. Spiritual diciplines that
will not neccessarily make the rains come, yet will
help with weed control.

Often in seasons of drought the only things that
flourish seem to be the weeds.

I recently talked with a landscaper at ACE hardware,
and she shared with me that even though the grass
is dormant (often appearing dead), it is good to cut
it on some sort of cycle to prevent the weeds from
taking over the space where grass can grow.

In taking careful perspective of what is in my own
"lawn," so to speak, I am noticing that during this
season of waiting, I have begun to see the evidence
of doubt, frustration, weariness of spirit, burnout.
My old friend fear even popped back for a visit.
Weeds that are hindering my own spiritual growth.
Nothing specific seems to be the cause, but one
thing I did identify was the carrying them in my
own strength. There goes my wandering heart . . .

I have so much to be thankful for. Just breathing is a
miracle! Google just gave me physical proof! There
is so much to praise the Lord for. Still even more to
pray for as needs pile up week after week. Is it any
wonder that this world needs a Savior? He still
calls to His sheep to come. Lay down your weary
head and rest. Let Him have it. He is faithful. He

always finishes what He started. His Word is full of instances where this is evidenced again and again. His timing is not always ours, and some of our unanswered prayers could be His biggest blessings in our life.

I was humbled as I read. Recalling exactly how I was feeling during that time makes me feel vulnerable. But, as I remember, I also see how far I have come, and where He is taking me. Step by step. Not the big picture, but I trust Him with the big picture as much as with the small step now too, and I suppose that is where He is leading me: down a path of faith.

I don't know what the grass looks like on the other side of the fence, but I do know this: It is never greener than when it has been tended by the Master. His will, His way. Let His timing be a rest for your soul. He's got it in His hands. His control. He will come through. He is ALWAYS there. He hears. He knows. And He is in the miracle business.

I wanted to remind you all of these great things about the Lord to encourage you. Tardy slips and lunch money orders are keeping me hopping as I write. Life through the school window is showing me much.

Just look outside and remember: in my season of physical and spiritual drought . . . He brought the rain. He'll do the same for you.

My One Thousand Gifts

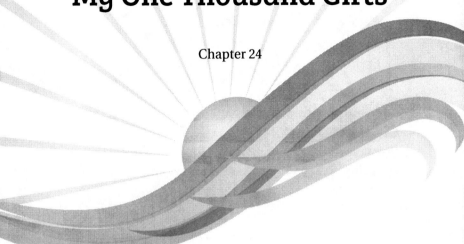

Chapter 24

"Bless the Lord, all his works, in all places of his dominion.
Bless the Lord, O my soul!" (Psalm 103:22 ESV)

I love to read.

If I am honest, I love the sappy, happy-ending kind of books. You know, the love stories, the feel-good inspirationals and historicals, and the real-life biographies—if they have a happy ending.

Every book I read is always a "good one." I have a little well-known secret: BEFORE I read it, I like to look at the last chapter and read through the ending. I know, I know . . . I get that sort of reaction all the time. I can handle it.

Do you know my favorite story?

My own . . .

Almost ten years ago, on May 29th, I married my best

friend. Though I couldn't see the last chapter, I could only hope then what I know now to be true—it is going to be incredible!

A story of hope and peace.

One of redemption, and one of joy . . .

Ecclesiastes 3:1–8 tells us that there is a time for everything.

There is a time to give birth . . . uproot . . . plant . . . heal . . . weep . . . build up . . . laugh . . . dance . . . embrace . . . let go . . . keep . . . throw away . . . silence . . . speaking . . . searching . . . to mourn . . .

There is a time for everything under the sun.

Just as you do not know the path of the wind and how bones are formed in the womb of the pregnant woman, so you do not know the activity of God who makes all things, sow your seed in the morning and do not be idle in the evening, for you do not know whether morning or evening sowing will suceed, or whether both of them alike will be good . . . Indeed, if a man should live many years, let him rejoice in them all, and let him remember the days of darkness. Ecclesiastes 11:5,6,8 New American Standard Bible)

We mourned the stroke that took so much from Aaron's dad, but rejoice that he is still with us, and through this we are able to see many examples of leadership, godliness, and that by serving one another we can truly become free.

We built our dream home . . . and sold it a couple years later.

We moved . . . and then moved again. Only to be moved soul-deep into greener pastures with the Lord.

We embraced these two . . . and had to let them go . . .

Only to be knit back together with their family two short years later . . .

They have been the worst of times . . .

And yet, the best of times . . .

"Consider the work of God, for who is able to straighten what He has bent?" (Ecclesiastes 7:13 NASB).

"For I have taken all this to my heart and explain it that . . . (everything we do and all that happens to us) is in the hand of God" (Ecclesiastes 9:1, paraphrased).

All of our endings with Jesus are always happy.

If I could do it all over again, I would. It has taken almost three and one-half years to say that (and there are still days where I'm not so sure).

In many ways, Aaron has been my photographer through these pictures. He has held me up and allowed the Lord to work through me, because he made the decision to trust the Lord when he was eight years old. And that decision to trust laid the firm foundation to trust Him again in this life, looking through the photo lens of the Father.

When I see this picture (which hangs on our living room wall), I have such bittersweet emotions. Tears fill my eyes. This was one month before learning of my cancer. However much I love this, I would never go back because I could have this picture, but never know what deadly disease I could still be sick with. Instead I choose to see the beauty in it. The wisdom of gray hair; the smiles that have "knowing" in them. The covenant

relationship that it represents. The crown of glory that the Lord has replanted on my head since this was taken.

Yes, we have experienced much under the sun. Like many of you. We have tasted and seen that the Lord is good (Psalm 34:8). We had heard of the Lord, but now our eyes have truly SEEN Him (Job 42:5). He has given us His wisdom and His behind the camera lens view with which we are learning to focus . . . and to leave you with one more thought:

"A man's wisdom illumines him and causes his stern face to beam." (Ecclesiastes 8:1b NASB).

Within these (almost) ten beautiful years lay more than one thousand gifts. Ann Voscamp paints an incredible word picture in her book aptly named. These are just a few of mine.

I look forward to counting the thousands more.

Learning to Sing Again

Chapter 25

"The flowers appear on the eart, the time of singing has come" (*Song of Solomon 2:12 English Standard Version*).

C all me crazy, but there is something quite refreshing, yes, even healing in getting your hands dirty and planting beautiful, new plants. The same shock they experience the first few days/weeks is quite like my own as I reflect on the past three years.

Several months ago I began planting plants, almost on the verge of developing an obsession. I dislike starting something and leaving it unfinished. When we moved into this house last year we left the front landscaping bare after we poured time, sweat, and money into redoing the whole front and back landscaping area of the house. New cedar logs, black paper, river rock, mulch,

more river rock, etc. One year later I am back at it with a vengeance. I am not your typical planter. Symmetry has its place, but in my garden you will find a blend of the unique, the great, the small, but beautiful, each and every plant. After many hours of choosing just the right plants and multiple bills later (not to mention a load of frustration from my man as I decided and decided again) I am finished with the front and now working on the the back. This is a larger project and more difficult to decide on, so I will be at this a while. I know, shocker, right? As much as I love plants, I hate to watch them go through the transplanting shock. And much like the shock the plants go through, they (like their gardener) need tender loving care daily from their master. Water, support, or fertilizer . . . He knows exactly what is needed to pull them through. Sometimes I am convinced whether plant or person, maybe what we need is simply the blessed touch of Jesus. The gentle lifting up of a head bowed down.

I have been busier than I have had to be in a while, it seems. Though I am healthy and getting stronger every day, I will admit that this last couple of weeks found me taking lots of naps, sleeping late when I could, and often going back to bed after my sweet friend Melissa picked the kiddos up for school, on her days for carpooling. I used to be ashamed of such habits in my life, but I have learned that to be the best mama I can be, I need to take the time to listen to my body and be the healthiest mama I can be. "Getting stronger" doesn't mean that I am "there" yet. But I am on my way . . . and anyone knows that when you are strength training, it is often the best not to power through the pain or the

tiredness. To avoid injury, one must rest.

During this season I noticed something. Every season has its good times and the not so good times. I'm finding that I don't want to deal with the shock factor that had come into my life from being transparent and being transplanted. I needed that tender touch. That "just the right kind of care" sort of touch.

My writing deadline was coming up.

Cade's birthday was fast approaching.

T-ball was in full swing.

And Mother's Day was here again.

I found myself remeniscing while driving with a friend one morning. We were driving in her car towards a shopping center and we had just driven past the Imaging Center for Women where I had been diagnosed. Instantly my mouth opened and tears began to fall unchecked as memories, painful ones that I had never visited, came flowing out . . .

I remember walking across that parking lot, the nurse holding my films. I didn't even want to touch them. They were changing my life in a way that I never wanted. I thought to myself, "This cannot be happening." I cried against the steering wheel of Aaron's truck for ten minutes. It was the kind of crying that leaves you hoarse and you never made a sound. The prayers unspoken, being interpreted by the Spirit as only He can.

Calling Aaron and asking him to meet me before his class started.

Calling and telling my parents that they suspected cancer and tests would soon follow.

My best friend being out of town, I called her, hearing her grief as she tried to be strong for me, telling me she loved me and that things were going to be okay. Hearing the faith she tried to put into her words as she was choking over her own grief for me.

Feeling so alone, but at the same time feeling safe . . .

My sweet friend . . . while driving, just listened. I am sure I had her worried!

Everywhere I looked last week, I saw new life: flowers, babies, and expectant mothers. And right there, along with those memories, the Lord touched a tender spot in my heart and began transplanting my old thoughts and replacing them with new ones. Remember the tender touch that was needed for this bowed head? He came, and He lifted me.

Sigh of thankfulness.

You know of our journey with trying to adopt. To save you a long story, to this point of our lives it has been unsuccessful. Cade is our little miracle baby and we are so very thankful. To date, we are still waiting. Only the Lord knows just what lay ahead for us. And so we wait. Basking in His tender care.

I have come to appreciate so many people in my life that have such displayed such strength. Those women who like us all have the echo of eternity in their hearts, yet wait on the Lord as their God-given roles as mothers

become questions. Empty arms cry desperately to be filled.

I am not an expert on any of these things, nor have I ever experienced even half of what most women have, yet I have had some dreams go unfulfilled that I believed were from the Lord. I have often found myself asking, begging, and even pleading with Jesus to answer my hearts cry, especially in the area of children.

There is no guesswork in the questions of whether or not this life is difficult. "Duh," as Cade would say.

The Lord has shown me time and time again, that nothing in this world can make me less of a woman. No mastectomy. No hysterectomy. No certain number of children. No amount of friends. No lack of estrogen and no barrenness of womb . . . NOTHING can make any of us less than a woman.

The world will tell us a different story.

The tender, loving care that this girl needed was gently wrapped in a single word: contentment.

Do you know what?

I have NEVER felt more feminine than I do right now. Right in this very moment of my life. Girly. Womanly. Loved. Cherished. Yes, even bridelike.

These crazy years have brought a lot of changes for me. These scandalous years have taught me so very much. More than could fill this book. Moments that I will treasure forever in my heart.

To say that this lifted head has found a new purpose would be an understatement. We were made for more than just what this world offers. More than just what this world thinks makes us a woman. Though our arms

are empty, and dreams seem lost, HOPE has come in the form of this . . . a *little baby*, Who saved the world. Who looks at us with love and sees our barrenness of soul and responds by honoring us who long for a child, with a child of His own. One that has the power to fill our hearts and save our soul.

You see? He did give us a child. Jesus. The Hope of Earth and Joy of Heaven. Love come down. Regardless of challenges that we face, yes, even cancer, He is there. He cares, and He will use it to work in us all that we need to live.

Many times I still need that change of perspective. I often find myself looking down, and still He lifts my head. After all this time He continues teaching me. Kind of like the tuning of an instrument. It takes time, accuracy, and pressure, but what is brought forth is perfect melody in perfect pitch.

This Jesus girl is learning to sing a new song. Attempting to find my wings. Adjust to the new normal. Accept things that I cannot change and I just don't find acceptable. Like the flower's transplanting shock, our lives are continually growing. Changing.

My heart still sings in the quiet of night, something I imagine Mary's doing so very long ago in the stable as Jesus was born. I am sure it was disappointing to deliver the King of Kings in a stall. Yet as she gazed in the eyes of Jesus, she looked past the mess, and filth around her. Past her disappointment and rejection from others, and saw in His eyes Emmanuel. God with us. I know, because I experienced the same thing.

I have learned to treasure my walk with Jesus in my heart.

I have had to learn to laugh again like Sarah.

I had to learn to pray again like Hannah.

I am learning from women who long before me were waiting on a promise that He kept. He is never late, and if He promises something, He is sure to deliver. I am preaching to the choir here, I know, but I have tasted and seen. I have begun to hum a new song. Something unknown, yet catchy.

I know that many a Mother's Day will pass, but as we are encouraged in scripture, comfort the motherless, the childless, the mothers in your life. Honor each one as is appropriate. Because whereever they are at in their walk through this life, they are changing the world. They are carrying out their God-given destinies. They were made for more than just a day and a title. They were made with eternity in their hearts and are teaching us much about faithfulness, love, trust, and hope. May that day serve, from this day on, to remind us to tune our own hearts to sing His praise.

However the sheet music is written.

A Postlude

Chapter 26

God's Promise

I had just finished this book. Literally. I had hit the send button earlier in the week, and then began the task of painting our spare bedroom. Yellow over green. Not a great idea, but after three coats, I can say that it covered. Almost.

My plans were to use this particular room as an office for writing, or maybe even a craft room. We were content and quite confident that the Lord was holding firm on His answer of *no* to any further adoption plans. Aaron and I felt called to a church directly around the corner from our former church. He was called to pastor. *Crazy* would be a great word here because this was not something that we were seeking out. After school and retirement? Yes. Right now? No.

As much as I try to avoid a drama-filled life, it always follows in one form or another. Inevitably, we find ourselves just shaking our heads, over and over again. Life is *never* dull. At least around these parts.

After three months of adjusting to our new surroundings, the Lord threw another title into the juggling mix. Two phonecalls, and one very unbelievable meeting later (that took place the next day), Aaron, Cade, and myself were chosen to be the adoptive family to a sweet, perfect, unborn baby girl.

Over the next three weeks that preceeded her arrival, our emotions ran the gammut. Disbelief. Joy. Shock. Fears. All of them were either put to rest or abounded more when our sweet baby Libbi was born on February 1st. All eight pounds and thirteen ounces came out healthy and loud. Her full name Libbi Rachelle, is a testimony of what it means: God's promise—fulfilled.

How completely like God to give a breastless, barren woman—who at times thought her life was over—a new baby to love, nurture and protect. I mean, how can you hug a baby without drawing it close? Such an amazing picture of how He holds us! How unmistakably good of Him. He is so much better than He has to be. So much better than I deserve.

In the first few weeks of her life, Libbi was able to meet and be loved on by our sweet friend Sherry. As she held her, Sherry told her to sing. She sang to her. She encouraged her to praise God and never let Him out of her grasp. She then looked at me and said, "Teach her to sing, Erin. Tell her your story. Tell the world your story. You have seen the goodness of God in the land of the

living, and the world needs to hear about Him. It's Gods gift to you. Take it and use it."

Sherry lost her battle with cancer shortly after meeting Libbi, but she won the ultimate victory. She stands whole before her Maker and is being loved on by the Lord and her sister. She was one of the biggest visionaries for this book to be transfered into print. Her warrior spirit lives on in the hearts of those who knew her.

Yes, God keeps His promises. Down to every last detail.

He uses whatever means for us to be sorted and sifted so we can see clearly that we are His and He is very much in love with us. The Maker of the heavens? He is calling to us. We are His *beloved*. Yes, the Creator of the Universe desires to have a relationship with you. With me. Whatever you face, you can rest assured you will *never* face alone. He stands ready. Unaffraid.

He will take you through valleys low and over mountain highs but NEVER where He isn't present.

So, you'd better hang on. This girl is learning how to breathe underwater. And just as I've written, He won't stop at anything, and He'll use everything. He doesn't need me to tell you this. My job it to simply echo what He's doing in my life.

He isn't confident us or in our ability to trust Him—but in His ability to bring us through anything—even if it's through waters deep.

A Note From My Hero: Aaron

The following questions are a few of what I have asked Aaron to share his thoughts on. These are his words, not mine. Untouched and raw at times, but the unspoken strength between the words themselves is what I hope you hear.

1. How did u react to Erin's diagnosis?

I think I was in shock initially because it was something we have never experienced or expected. I felt horrible for her as she sobbed into the phone the day she was give her diagnosis. I thought about all the things that she would have to go through and how that would affect our family life. But never, at any point did I think that this would cost her life. I just thought that we would pull together as a family and do what ever hard work was necessary to bring Erin through this time.

It was a shock though, something that none of our friends had ever gone through as a couple, so I think in some ways we felt isolated; and Erin as an individual her age going through it. I was so proud of the way she really shone Christ through the whole process. On the day of her surgery she got up super early and got all fixed up in case she met her Savior that day. How she befriended every doctor and nurse and quickly became everyone's favorite patient. And how she got to know and ministered

to the older people who were going through chemo with her; some of them with a much less positive prognosis. Looking back I can really see Gods hand of provision as well. Just how He provided the early diagnosis in a fluke way and though we knew nobody in this field, He provided Erin with the best doctors. He allowed her not to be too sick with her chemo and gave me the strength to be able to do for her whatever I could without losing it too often. He gave her friends who would walk through this with her and help get her to her appointments. He also provided us with great insurance through my employer so that the cost didn't ruin us financially. God was in this and just asked us to trust Him and follow His lead.

2. How did you feel about the aggressive treatment being prescribed?

In no way was I upset that they prescribed an aggressive treatment plan. I thought Erin was young and healthy and could handle it. It made sense when the Dr described that its all about how many years they're trying to get for the individual and I knew they had to try to get Erin a lot! I also think they "under treat" people sometimes after a surgery so I was glad they threw the book at her.

3. What disappointments did u face with this journey?

I was disappointed for her when her life was interrupted this way and that she had to go through all these surgeries and recoveries. I was not disappointed in the level of care she received. I was somewhat disappointed when

we had to postpone adoption plans we had been making for several years. The greatest disappointment for both of us, though, has been that you never get back to your old self again, it's about her learning to manage her 'new normal'. She has frequent check ups and re-evaluations that cause her to live inconstant fear of the numbers going back up indicating that her cancer has returned. She has had to take a lot of medicine now, including anti-depressants for a time, whereas before she was always a very healthy and happy person. She still is, but things are different. The chemo caused her to lose her hair and gain weight which she now struggles to lose as they continue to suppress her hormones. Her breasts were removed and now replaced leaving long scars across her chest and an unnatural look. So this ordeal has drastically affected her appearance. This has resulted in tension in our marriage as I deal with my feelings toward this new reality and she deals with her fears that I may someday reject her because of it. The old saying is really true: you're never really cured of cancer . . . or it's lasting effects. But we are not without hope; because God is good and ever-present, even through the waters deep.

CPSIA information can be obtained at www.ICGtesting.com
Printed in the USA
BVOW04s1954170414

350976BV00006B/26/P